# DERBY
## IN
# 50
# BUILDINGS

# GERRY VAN TONDER

AMBERLEY

First published 2016

Amberley Publishing, The Hill, Stroud
Gloucestershire GL5 4EP

www.amberley-books.com

British Library Cataloguing in Publication Data.
A catalogue record for this book is available from the British Library.

ISBN 978 1 4456 5815 5 (print)
ISBN 978 1 4456 5816 2 (ebook)

Typesetting and Origination by Amberley Publishing.
Printed in Great Britain.

# Contents

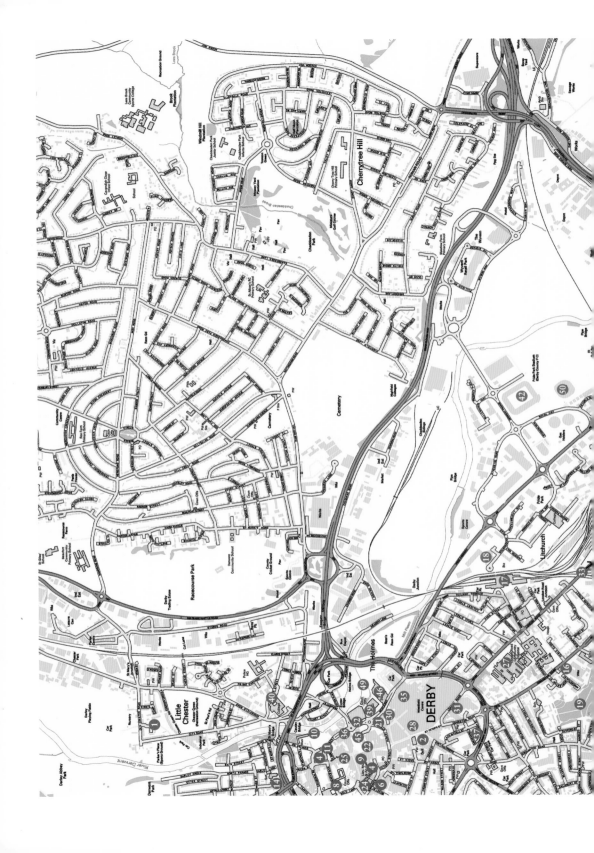

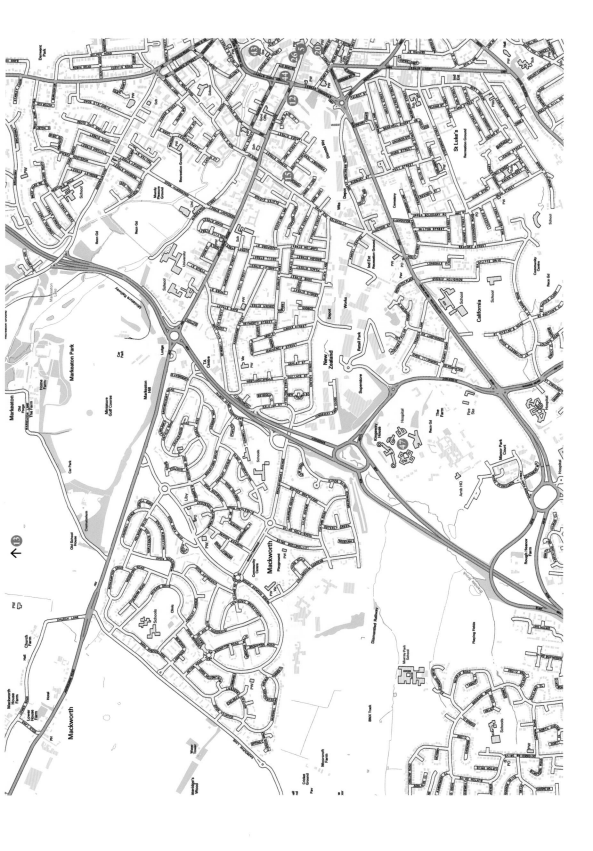

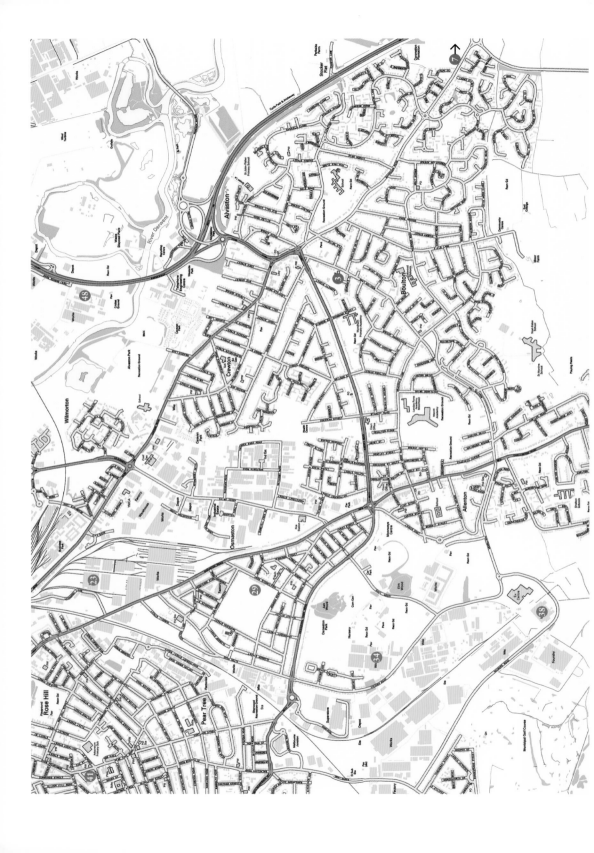

# Introduction

In the Christian calendar between AD 100 and 200, the occupation forces of Roman Britain established a military revictualling military and trading station, Derventio, at a ford across the Derwent.

Two centuries after the demise of Rome's hold over the Britons, Saxon invaders levelled Derventio, forcefully asserting their authority over the settlement's erstwhile owners. The defensive site, named Northworthige by the Saxons and bounded by the Derwent and several streams, witnessed the growth of primitive industries.

In 597, the monk Augustine arrived in England, sent by the Papacy on a mission to convert the Anglo-Saxons to Christianity. As pagan worship yielded to the new religion, church buildings started to appear throughout England, typically basic structures made of wood. In the centre of Northworthige, St Werburgh's was constructed, providing a focal market point for traders and farmers to conduct their business.

In the ninth century, the much-feared Viking coastal raiders moved inland, and in 874, this warring wave of plunder and pillage overwhelmed Northworthige. Forty years later, the female warrior, Ethelfleda, gathered a strong enough Saxon army to drive the Danes from the village. Less than three decades thereafter, however, the Danes reclaimed their ownership, but this time compromise was the order of the day as Dane and Saxon elected to live together under one common law. Exercising their political majority, the Danes renamed the village Derby – the 'town on the water'.

Over the next century, under the protection of the law of the Danes, Derby underwent a period of prosperous commercial and social growth. As the town's boundaries expanded, other churches were incorporated – St Alkmund's, All Saints, St Peter's, St Mary's and St Michael's.

The Norman invasion of 1066 and the death in battle of the Saxon King Harold, brought Saxon rule to an abrupt end. The agricultural town of Derby started weaving its own cloth and grinding its own corn in small mills. A corn market was established close to the St James' monastery conglomeration of church and agricultural buildings.

As the thirteenth century drew to a close, the Friary in Derby had significantly grown in wealth, which not only allowed the Black Friars to enlarge their buildings, but also enhanced their political status and clout. The Abbot of Derby, however, eclipsed these monastic revivalists, becoming a substantial property

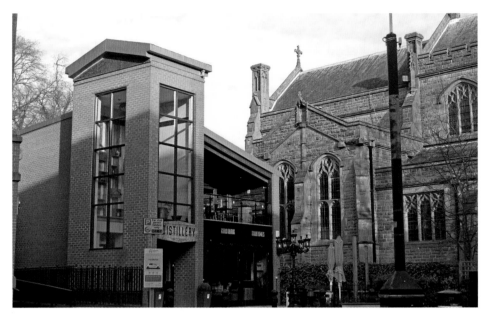

The old and the new – 5 metres and hundreds of years of history separate St Werburgh's from her modern red-brick neighbour.

owner, assisted in no small measure by the grants of land and property from a now wealthy merchant class in Derby.

As disputes grew over taxes and agricultural excise duties, central control manifested itself in the courts of assizes, responsible for civil and criminal jurisdiction. The assizes were held initially in the County Hall at St Mary's Gate. By the middle of the fifteenth century, merchants and traders established their guild in the town hall, transforming its function towards that of a borough corporation.

During the reign of Henry VIII, radical changes in the English church arising from the Dissolution of the Monasteries, saw the wealthy contributing directly to the welfare of the poor, including the provision of so-called almshouses.

Agriculture and allied markets continued to fuel Derby's expansion, and by the 1700s, the town boasted large residences in Full Street, the Corn Market and the Morledge. A post office and several banks serviced the economy, while shopkeepers catered for the new wealth. The growth demanded significant improvements in the transport infrastructure. Turnpike roads were constructed and tollhouses sprang up to collect revenue from the road users. Coach inns proliferated, and bull-baiting, wild beast shows, theatres and fairs were held, as the town's 1750 population of 7,000 centred their lives on the Market Place.

Towards the end of the eighteenth century, in the early part of George III's reign, new buildings were commissioned, including the town hall and assembly rooms. In a town that still lacked street lamps – only introduced in 1792 – the town boundaries, however, changed little.

Pre-Reformation monks played a key role in the town. This wooden plaque can be seen at the Old Bell pub.

The next landmark event that would have a lasting impact on Derby's appearance came in the form of the Reform Act of 1832. For the first time in Derby's history, governance and political hegemony would be wrested from the pockets of a handful of wealthy property and landowners, to the borough's citizens. Derby was split into wards, and at the start of 1837, Joseph Strutt became the first democratically elected mayor. Parish workhouses were abolished, and replaced with the Union Workhouse.

With the dawn of the Victorian era, Derby also developed a taste for magnificent and attractive architecture. This style, symptomatic of the prosperity of the nation as a world economic power, prevails even today in the streets of Derby.

The late 1830s would have a profound and lasting impact on Derby: the railway had arrived.

Iron and engineering works sprang up to cope with the demands of this revolutionary and efficient method of transport. New mills were built and the manufacture of Derby Crown china revived. New streets were laid and existing ones widened. The market place expanded and, gradually, Derby started losing much of its historic appearance.

Continued growth in the town's population size meant flour and wheat had to be brought in by rail, Derbyshire farmers no longer able to meet the increased demand.

Typically, however, the increase in wealth had an undesired by-product: the poor; members of the Derby community who gained no benefit from industrial prosperity. Legislation was promulgated to address the issue, but a major

The tools of the architect depicted above the doorway of renowned Derby architect Joseph Pickford's Georgian House on Friar Gate.

provision to qualify for aid, was for the poverty-stricken to move into the new workhouse on Osmaston Road.

Bicycles, motor cycles and cars started to arrive, and on the eve of the First World War, the town acquired its first motorised fire engine. Silk and cotton mills ceased production as mass factory production of consumer goods replaced traditional craftsmen. Foundries and factories sprang up everywhere.

The most profound event in the future economic strength of Derby, occurred in 1906 when Rolls-Royce commenced the manufacture of that icon of luxury motoring: the Rolls-Royce. The company's factories and offices spread from Osmaston Road to other parts of the city, an expansion accelerated by their highly successful venture into aero-engines. The company would evolve into becoming the single largest contributor to the town's future wealth and economic security, something that is reflected in many of Derby's buildings.

# The 50 Buildings

Archaeological evidence points to the presence of a Roman military camp on the western bank of the Derwent River, dating back to shortly after the Roman general Aulus Plautus landed with his army of 40,000 in AD 43, to seize Britain and assimilate the territory into the Roman Empire.

Towards the end of the century, the Romans established a permanent fort on the east bank of the Derwent, naming the cantonment Derventio. The site is today known as Little Chester.

Considerable quantities of late fourth-century Roman coins, bearing the effigy of Emperor Theodosius I, confirmed that Derventio flourished on a well-established cash economy. Regarded by the English Heritage as an important '*fort-vicus*' site – provincial administrative neighbourhood – a civilian settlement, lured by the power of Roman coinage, sprang up next to the fort. In this manner, local Celtic tribesmen became incorporated into the Roman way of life.

One of two ancient Roman wells preserved in Little Chester, where the occupying force had erected a stonewalled garrison.

Towards the end of the third century, a stone wall was erected around Derventio. The remains of pottery kilns and evidence of ironworking have been discovered at the site. Five Roman mausoleums were also found in what would have been the fort's cemetery.

Almost nothing remains today that would suggest Roman occupation in the past, apart from the sites of two third-century wells in what is today Derby's oldest suburb – Little Chester, now more commonly called Chester Green. One such well is situated in the St Paul's Church vicarage, the other on Marcus Street. The latter is in a modern housing estate where, during the construction of flats, an old Roman stone building was discovered as well as a 9-foot-thick section of Roman defensive walling.

## 2. St Peter's Church (1042)

By the start of the tenth century, the Danish occupiers, now converted to Christianity, had constructed four churches in Derby. St Peter's was one of these; the site in the fledgling town providing a convenient location for the Church's regional base.

A hundred years later, the Normans, not only enthusiastic about their Christian faith but also renowned builders, demolished and reconstructed Derby's churches in their own robust Gothic and Norman architectural style.

The city centre church.

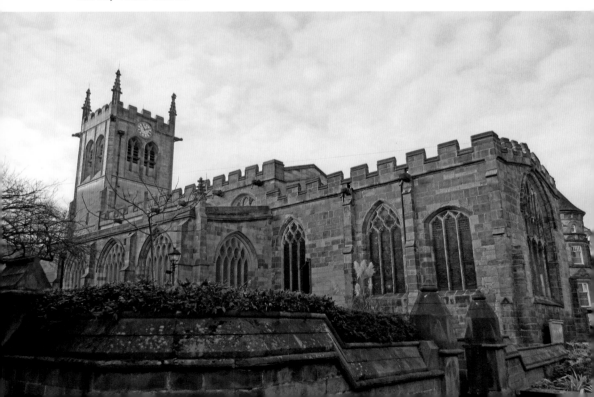

Although significant changes were made to the building in the mid-1300s when rebuilding took place, certain Norman features remain. Early in the sixteenth century, the steep roof was lowered, the chancel arch widened, new windows added, and the tower rebuilt. The bells – their toll so well known today – were hung in 1636.

Through the second half of the 1800s, considerable work was done to restore the building to some semblance of its historic character: the chancel was restored, plaster removed to expose the old wooden roof beams, and the tower completely rebuilt in the style more befitting the church's age.

Today, this Grade II-listed building stands at the heart of the city's Business Improvement District, named the St Peter's Quarter. As the name suggests, the council-led initiative introduced in 2011 has as its objective the promotion of the area in an attempt to lure lost footfall back to the city centre and, in doing so, safeguard the area's economic viability.

The following year, the Derby City Chaplaincy embarked on a programme of reinstating St Peter's as a centre for community service, introducing a wide range of services of worship to reinvigorate its 1,000-year-old status as a fully functional Christian church.

## 3. St Mary's Church, Boulton (1100s)

The Boulton Township was listed in the Domesday Book of 1086 as being owned by a Norman overlord. The Sacheverell family subsequently acquired the property. It is generally believed that they were the founders of the Boulton Church – dedicated to the Virgin Mary – as records show that, during the reign of Henry II (1154–1189), the family initiated an annual grant to the church by donating twelve shillings.

In 1271, Sir Robert Sacheverell, on the basis that the Boulton church was independent and not simply a chapelry of St Peter's in central Derby, claimed that he was entitled to appoint a new chaplain as the position had become vacant. When the Darley abbot, William de Wymondham found out, an acrimonious dispute ensued, the abbot adamant that Boulton Church was a St Peter's chapelry. The issue was eventually resolved through compromise and financial settlement, and Boulton Church was now officially a chapel of ease for St Peter's.

The Reformation brought with it major changes, not least of all the right of the Crown to confiscate church endowments, including ancillary buildings. Exercising this right on behalf of the monarch, the Duke of Somerset duly confiscated the chaplain's house and all endowments received by Boulton Church from the Sacheverell family.

This sudden loss of revenue forced Boulton Church to become a shared beneficiary with St Michael's and All Saints Church in neighbouring Alvaston, a relationship that lasted until 1884.

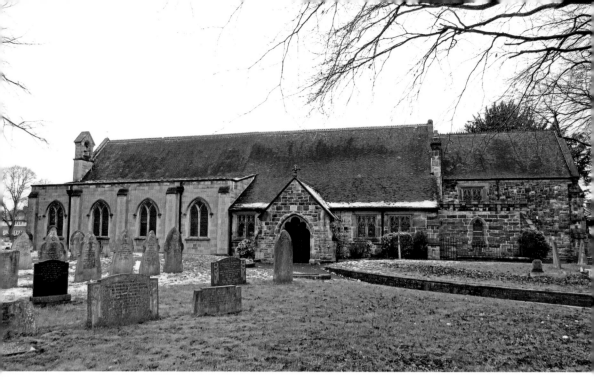

Winter adorns St Mary's church and graveyard.

Apart from the south doorway and a window, the church was almost totally demolished and rebuilt in 1840 by John Mason of Derby, to accommodate a growing congregation. Further extensions were added in the latter half of Victoria's reign and again in 1907.

Boulton Church now forms part of the Diocese of Derby. The building undergoes a mandatory structural inspection every five years.

## 4. Ye Olde Dolphin Inne (1530)

Situated in the Business Improvement District, the Cathedral Quarter, Ye Olde Dolphin Inne is the city's oldest public house. Dating back to 1530, amazingly very few changes have been made to this historic gem – period wooden beams, foot-worn stone floors, wooden interiors and leaded windows have all survived.

At the time when the 132-ship armada of King Phillip of Spain was forming up off the coast of Calais, in preparation for a planned invasion of England to overthrow the Protestant monarchy of Elizabeth I, Derby had no fewer than seventy-six public houses: one for every forty of its citizens.

The town brewed its own ale, but perhaps the burgesses had no option but to savour this local tipple as it was generally all that was available. In 1699, during Charles II's reign, there was an occasion when the town's finest brew was sent to London where, in the satirical words of one T. Brown, it was not favourably received. A sample verse from his *A Sot's Paradise*, or *Humours of a Derby*

*Alehouse with a Satyr upon the Ale*, suggested, in no uncertain terms, that the city's ale had a bleak future:

> Base and ignoble flegm, dull Derby ale:
> Thou canst o'er none but brainless sots prevail;
> Choke them if new, and sour thou art if stale.
> Thou drown'st no care, nor dost thou elevate;
> Instead of quenching Drouth, dost Drouth create;
> Makes us dull sots at an expensive rate.

The Dolphin, as it is commonly called, was first licensed as a coaching inn, and most likely also served as a stopping-off point for highwaymen.

In a city that has the dubious status of being the most haunted place in Britain – today offering night-time 'ghost walks' – it comes as no surprise that the 500-year-old Dolphin has its fair share of things ghostly.

A story is told of a doctor who, in the eighteenth century, was lodging in a part of the Dolphin building set aside for this purpose. Whether the young surgeon wished to further his skills with the scalpel or was simply a twisted psychopath is not known, but late one night a pair of body snatchers secretly dropped off a corpse of a young woman on which the doctor could 'experiment'. Setting about his gruesome curiosity in the cellar – below what is today the lounge – the doctor had already opened the woman's stomach cavity when, so the tale goes, it

The haunted Dolphin.

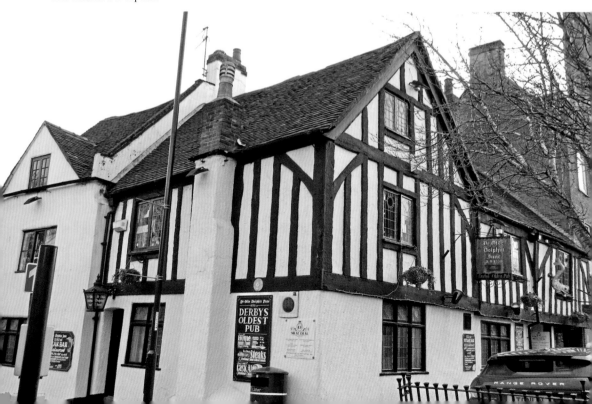

transpired that she was in fact still very much alive. Leaping off the table, the hapless woman, screaming loudly like some banshee, started running around in the cellar. Trailing her intestines behind her, she eventually succumbed to her brutal injuries.

It is said that the doctor lost his sanity as a result, and was committed to the local asylum. His wealthy family ensured there was no evidence of the murderous event. It is said that the terrified screams of the young woman can occasionally still be heard on pitch-black, moonless nights.

In the 1950s, several patrons of the Dolphin said they saw an apparition of a Highland warrior, sword in hand and a woman riding on his back, charging down a passage that bisects the pub. In December 1745, Charles 'Bonnie Prince Charlie' Stuart had arrived in Derby with his Scottish army, of whom some found accommodation at the Dolphin. Was the ghostly, kilted fighter one such Highlander?

## 5. St Werburgh's Church (1601)

Founded in the seventh century, St Werburgh's was the first Christian church in Derby, less than 100 years after the first Christian missionary, Augustine, had arrived in England. The building would have been a crude, thatched wicker and daub structure.

St Werburgh, who died in AD 700 was, at the end of her life, senior abbess of the kingdom of Mercia. The daughter of King Wulfhere and Queen Ermenhilda

The 1601 St Werburgh's clock tower abuts the newer church.

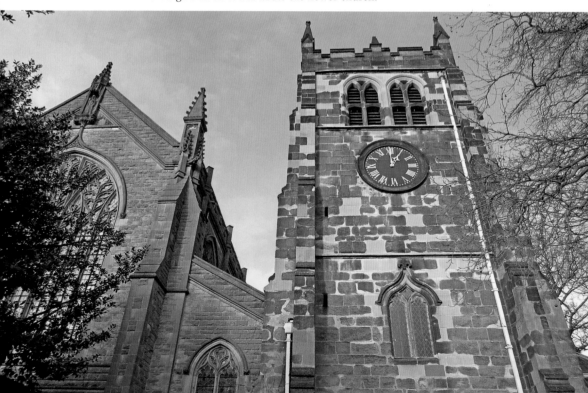

of Mercia, she took the unconventional step to become a nun, and although her father wished her to marry, he eventually relented and gave his permission for her to enter Ely Abbey. The Church Calendar now celebrates Feast Day annually on 7 February, to commemorate the day of her death.

The church was rebuilt towards the close of the seventeenth century, with the 1601 tower being retained. Staffordshire-born lexicographer, poet and biographer Dr Samuel Johnson married Elizabeth Porter (née Jervis) in the church in 1735.

Rebuilding work on the rest of the church commenced in 1893. Designed by Sir Arthur Blomfield in the Gothic Revival style, 'Rough Rock' sandstone for the construction came from the nearby Coxbench quarry.

In 1990, the building was declared redundant and the inside of the building converted to commercial use. For a brief period, the church was used as a shopping mall, comprising small stalls. The venture never really took off, and access to the building is now restricted. With the church and its cemetery no longer in use, the headstones have been propped up against the outside walls of the building.

Today St Werburgh's, its tower refurbished in 2004, owes the fact that it is still standing to its Grade II-listed status. Volunteers from the Churches Conservation Trust look after the tower and original chancel, keeping in a good state of repair the 1708 reredos with its ornate panels and Queen Anne's Coat of Arms overhead, as well as the stained-glass window and a monument to Sarah Elizabeth Winyates who died in 1828. This 1832 neo-classical figure of a woman in mourning is by prolific English sculptor, Sir Francis Chantrey, commissioned at a cost of £600.

Highly ornate reredos and stained-glass window in the east side of the chancel.

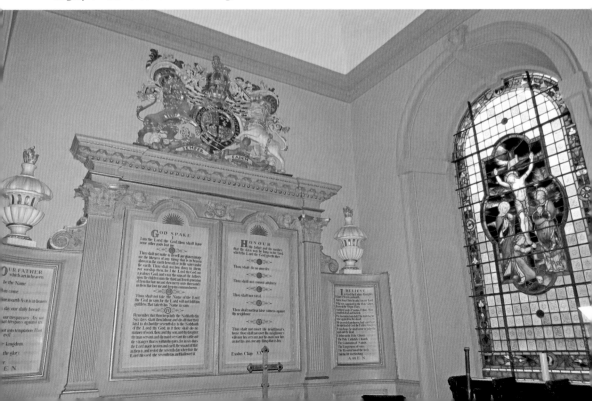

6. Jacobean House (1611)

This magnificent Grade II-listed building in the Wardwick, was Derby's first brick building. Previously known as Gisborne House, named for the family who it is believed rebuilt and occupied the Robert Smythson-designed building. The family were the owners of a lucrative animal-hides enterprise in the mid-sixteenth century, before diversifying into the production of malt. Former Derby mayor, Francis Jessop, also lived there at one time. The house was once much larger, but the laying of Becket Street in 1855 literally cut the five-gabled building in two.

Named after James I of England, the Jacobean style, following that of the Elizabethan era, represents the second phase of Renaissance architecture in England. With the ascension of James to the English throne, Elizabethan styles of architecture remained in vogue. It was only after James' death in 1625, that there was a significant swing towards more Italian-influenced classical architecture.

True to Derby's reputation as the city of ghosts, the house boasts no fewer than fourteen spirits of the departed. Arguably, the most ghoulish is that of the headless coachman steering his coach-and-four through an archway.

Many Jacobean and Elizabethan buildings in the city have survived the rigours of time, but the façades of most were 'modernised' in the eighteenth and nineteenth centuries.

Derby's first brick building.

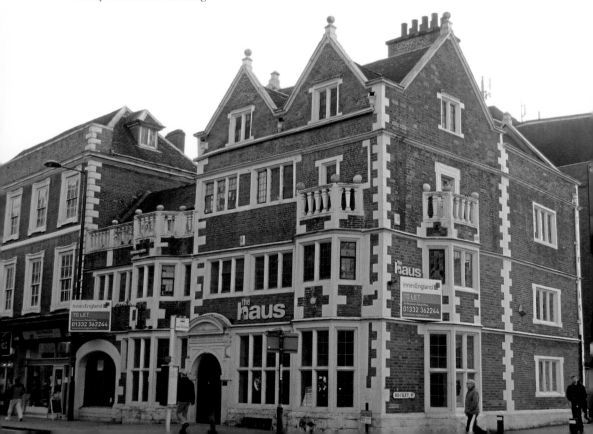

In consultation with English Heritage, internal refurbishment recently took place to accommodate a pub/restaurant. Many of the building's original internal features therefore remain, including wooden floors, magnificent fireplaces and rich wood panelling.

In March 2010, the city almost lost its unique building when a fire, which had started in the kitchen, spread to the bar area, causing significant damage to the historical ceiling. Fortunately the building was spared, after it took twenty-four firemen with five appliances around three hours to douse the fire that was threatening to reduce the building to a pile of ashes.

The tenants, trading as The Haus, were able to repair the damage and reopened their pub, only to later close their doors when they could no longer sustain the business. At the time of writing, the building remains vacant, another victim of changing social and economic behaviour being witnessed throughout Britain.

## 7. Elvaston Castle (1633)

Now owned by the Derbyshire County Council and run as a country recreation park, this striking Gothic Revival castle was originally built as an Elizabethan manor house by the High Sheriff of Derbyshire, Sir John Stanhope. He had inherited the estate from his father, also Sir John.

Early in the 1800s, the then 3rd Earl of Harrington, Charles Stanhope, commissioned renowned English architect James Wyatt to redesign the house in his favoured Gothic style, at the same time also adding a new wing and grand hall.

In 1836, the last structural changes to the castle's exterior were carried out when the south front, the only remaining Elizabethan-style structure, was reworked to match the rest of the building.

The 4th Earl of Harrington, besotted with his new, very young bride, spared no expense to have the gardens landscaped and redesigned, and so provide a secluded place of calm and beauty for them to have only to themselves. With the death of their four-year-old son, however, the devastated couple sought reclusive refuge within the castle walls.

When the fifth earl inherited the property, he allowed full public access to the gardens. Now commonly referred to as the 'Gothic Paradise', the gardens enjoy Grade II-listed status.

During the Second World War, the teacher training college in Derby was translocated to Elvaston Castle, but the college returned to the city in 1947. For twenty years thereafter, the castle remained largely unoccupied until it was sold off. Sadly, however, this heralded a gradual decline in the building's condition.

In 1969, Derbyshire County Council purchased the estate from the 11th Earl of Harrington, William Stanhope. Now named Elvaston Castle Park, the following year the council opened the whole estate to the public.

Since then, the council found it increasingly problematic to afford the enormous running costs, let alone the upkeep of the castle in a reasonable and safe state of

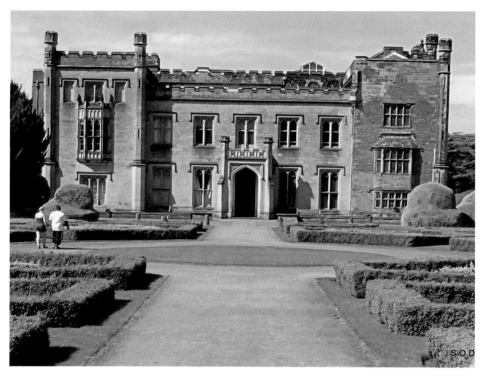

The castle clearly showing its age (photo courtesy of Friends of Elvaston Castle).

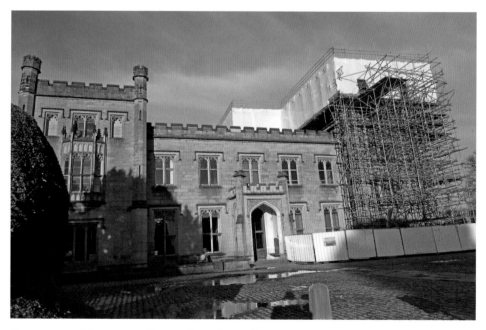

Current essential waterproofing work on the roof.

repair. As a consequence, in 1990, the council was forced to stop public access to the castle itself. Ten years later, the estimated cost to repair and restore the rapidly deteriorating castle stood at £3 million. Plans to have the estate sold off to be used as a golf course and hotel failed.

In 2008, Elvaston Castle was registered as a heritage risk, a designation that annually identifies protected buildings and structures that are at risk through decay and lack of upkeep. The survey also serves to prioritise the most vulnerable historical assets, and the provision of a database for urgent restoration funding.

Notwithstanding the fact that the castle remains inaccessible to the general public, the 320 acres of formal gardens, parkland and tracts of woodland, are a popular summer's day picnic venue for the people of Derby. Testimony to the council's dedication to maintain the estate in good condition can be found in the park being awarded the Green Flag award for 'well-managed parks and green spaces' for the last three years.

At the time of writing, scaffolding hides virtually the whole building as essential repair and restorative work is undertaken. With restoring the castle to that of a water-tight building, a temporary roof cover is being put in place to facilitate the difficult exercise of replacing damaged tiles. During this part of the project, centuries-old supporting timbers are either repaired or replaced, and external stonewalls repointed. Funded by the county council, the work, including to the clock tower, will only be completed well into 2016.

## 8. St Mary's Gate Shire Hall (1660)

Etwall architect, George Eaton, designed the main, stately structure with stone façade, set back from the road. Constructed in 1660 as the Shire and County Hall, it was primarily the seat of higher law courts known as Assizes, where Crown judges from London presided every three months.

The original 1724 decorative wrought-iron gates made by Robert Bakewell, would eventually be moved to the All Saints Cathedral's west door.

In 1811, a Judges' Lodging section was added, built from red brick and three storeys high. These legal emissaries of the Queen were accorded red-carpet treatment when visiting, where senior civil office bearers and the cream of Derby's landed gentry would meet them – often some distance from the town – and lay on stately carriages to convey Her Majesty's judges to their well-appointed quarters. Upon arrival at the County Hall, there would be an official opening ceremony, followed by a service in All Saints Church and an extravagant dinner of local delicacies.

The Royal Victorian purveyors of justice adopted a less inhumane regime in its tranche of punishment dished out to the county's citizens, although transportation to Australia only ceased to be an option by as late as 1870. An example of the fear that banishment to the distant colony engendered, occurred in April 1838, when twenty-two-year-old William Gaunt, convicted of horse theft, committing suicide in the county jail.

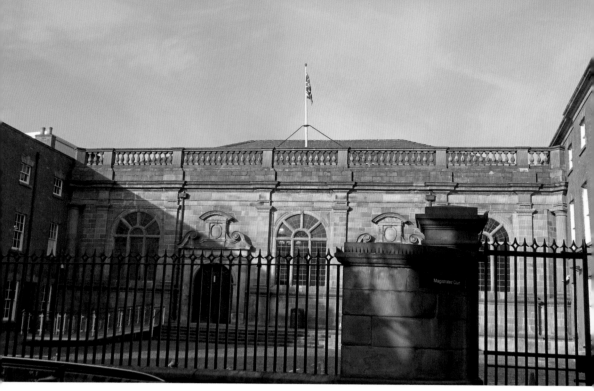

The Shire Hall on St Mary's Gate.

In 1841, the stately town house, formerly occupied by the Osborne, Bateman and Evans families, became a Baptist chapel.

This building was modernised in the 1930s. An early eighteenth-century inn, forming the south-western wing, also of red brick, became the police station.

Since renovated, the Shire Hall today forms part of the new Southern Derbyshire Magistrates' Court.

## 9. The Old Bell Hotel (1680)

With the dawn of the nineteenth century, turnpike trusts were maintaining roads in such a way that travelling by coach became easier and more frequent. Gates served all main arterial routes in and out of Derby, manned by collectors who rigorously enforced the payment of tolls for those moving through these points of revenue.

Short-haul mail coaches, called 'diligences', appeared, with the Derby to Nottingham diligence operating a popular daily service. Seats for three passengers were available on every trip. New mail-coaches introduced more spacious and comfortable travel to farther destinations such as London and Birmingham. As the coach-horn heralded the arrival of a coach, attendants and ostlers rushed out to receive the coach and horses into the courtyards and stables of coaching inns throughout Derby, with The Bell in Sadler Gate being a more famous one.

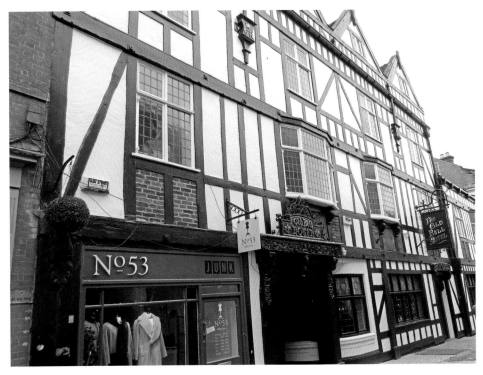

The Old Bell on the narrow, cobbled and bricked Sadler Gate.

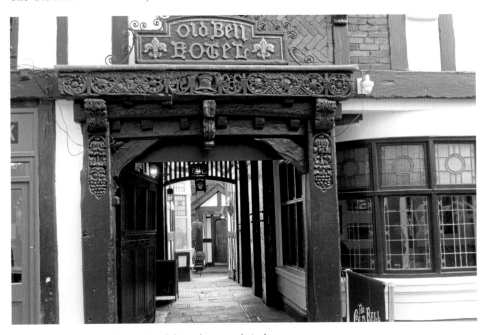

The coach entrance framed in delicately carved timber.

Built by the Meynell family in about 1680, the coaching inn would offer the weary traveller fresh oysters at three shillings an ounce, and a glass of the finest port at six pence.

With the arrival of train travel in the 1840s, long-distance coach services started to be withdrawn. On 3 November 1855, the Manchester–Derby coach pulled into The Old Bell yard for the last time.

The pseudo-Tudor black and white façade was only added in 1929. As part of this refurbishment, the Grand Regency Ballroom was created by knocking through three adjoining rooms.

From the 1960s through to the 1980s, the once plush ballroom lost its architectural beauty when it was used as a nightclub. The pub was closed in 2012 after a person was killed just outside. Since then, the new owner has sunk a significant amount of capital into an ambitious renovation programme for The Old Bell. With a strong desire to restore the ballroom's bygone splendour, the twentieth-century nightclub veneer was stripped away, revealing for the first time in decades, a magnificent glass dome and solid-wood floors.

## 10. Silk Mill (1718)

At around the time that Queen Anne ascended the throne, manual stocking-frames appeared in a handful of Derby homes. Shortly thereafter, Derby solicitor Thomas Cotchett procured silk-throwing machines from the Netherlands. To house his four machines – with a total of 1,340 spindles and 8,410 bobbins – Cotchett had a mill built on the Derwent, just behind Full Street, with a thirteen-and-a-half-foot waterwheel providing the necessary power.

Cotchett's venture was short-lived, however, and in 1717, twenty-two-year-old mill apprentice John Lombe returned from having spent two years in Leghorn, Italy, where he clandestinely recorded in great detail the workings of the efficient Italian silk-throwing machines.

With his half-brother, Thomas, financing the new venture, John Lombe took over the dilapidated Cotchett mill site, erecting new buildings, including a tower. Millwright George Sorocold provided the expertise for the manufacture of silk machines styled on the ones John Lombe had scrutinised in Italy.

A three-storey building was constructed to accommodate the 'winding', 'throwing' and 'doubling' processes. Separate rooms housed sorting and packing operations, an office, a counting shop and a brewhouse.

Derby and much of Britain were in awe of John Lombe's industrial innovation, but sadly, the inventor died at the very early age of twenty-nine. His half-brother Thomas assumed sole ownership and the business continued to prosper. For his services to the nation, parliament gave Thomas a knighthood and a gratuity of £14,000. Other mills sprang up in Derby as the Silk Mill expanded to employ 200 people.

The mill ceased production in 1890. A year later, the building had fallen into such a state of disrepair that demolition appeared to be likely. In a devastating

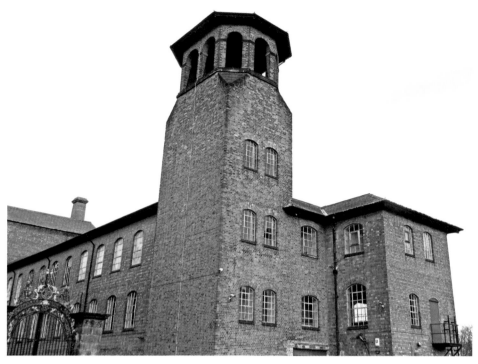

The well-preserved mill now houses a museum.

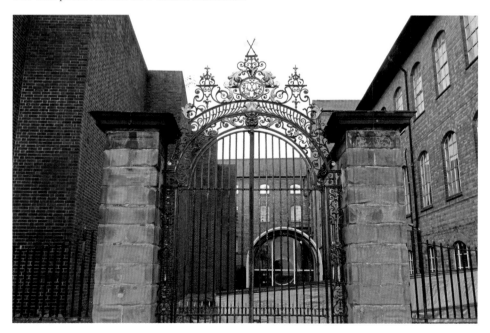

Robert Bakewell wrought-iron work.

blaze on 5 December 1910, the building was all but levelled in the inferno. In due course the structure was rebuilt, being used for a period as workshops and for storage.

It would only be in November 1974 that the future of the building was guaranteed, when the Industrial Museum assumed occupancy. The listed building stands proudly as a reminder that Derbyshire was the cradle of the Industrial Revolution.

Part of the UNESCO World Heritage Site, the building is currently closed to the public as the old mill undergoes substantial redevelopment to create a new interactive museum, which will display fascinating items from Derby's prosperous industrial past. Those who made the city will be honoured, their innovations used to further educational activities. The successes of the makers of the past will be designed to empower makers of the future through inspirational environments for learning programmes and activities. The development, called 'Project Lab', and which has the backing of the Heritage Lottery Fund, Derby City Council and Arts Council England, is due for completion by 2016.

## 11. All Saints – Derby Cathedral (1725)

The erection of the impressive All Saint's tower, begun in 1510 and taking twenty-five years to complete, provided Derby with a very prominent landmark on its skyline – one which exists to this day. Major funding came from the youth of the town, and from merchant benefactor and philanthropist Robert Liversage. 'Church ales', stage plays, games, and entertainment such as bear-baiting and Morris dancing, raised an enormous 25 pounds. John Oates was appointed master mason for the tower project.

By 1537, Henry VIII had completely severed any remaining links the Church of England had with Rome, championing the spread of Protestant reformation in England. Derby now boasted the finest church in the county, the building having expanded to include a nave, two choir stalls and five-side chapels. The interior was ornately adorned with murals and finely embroidered high-altar cloths, silver and gold chalices, candlesticks and crucifixes.

Edward VI abolished mass and required services to be held in English instead of Latin. Upon his death in 1553, however, his Catholic half-sister, Mary I (Bloody Mary), claimed the disputed throne and entered into a pogrom of anti-Protestant persecution. In 1556, Joan Waste, the blind twenty-two-year-old daughter of a Derby baker, was found guilty of failing to adhere to Catholic doctrines. On 1 August, she was led to Windmill Pit, just off Burton Road, where she was burned at the stake. The Church had lost its status as regional headquarters, unemployment was spiralling, and more and more were joining the ranks of the poor. Derby's townsfolk stood by in tacit resignation as Joan Waste met a brutal end.

With the passing of time and monarchs, the All Saints Church hosted a diverse range of ceremonies. By the mid-seventeenth century, Michaelmas Day was the

All Saints, seat of the Bishop of Derby.

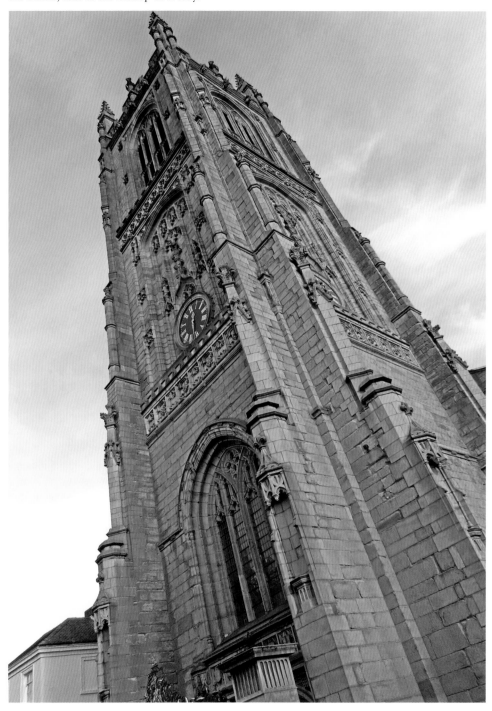

day when the town's four justices of the peace – who happened to be the mayor, his predecessor, and two senior alderman – would meet in All Saints to elect a new mayor among themselves. From the church they would walk across to the Market Place to announce the name of the new civic leader.

The period of the First English Civil War of 1642–46, saw the rapid rise to political power of the so-called Puritans, a movement which had as its sole mission the rectification of shortcomings of the Reformation. They were adamant that the Church retained too many Catholic practices. Strict observers of the Sabbath, when the Civil War broke out the Derby Puritans set upon All Saints, levelling the chancel to that of the nave, and destroying stained-glass windows, pictures and icons, and carvings. The old stone font was replaced with one of alabaster.

Over time, the condition of the church had been deteriorating to such an extent that the vicar, Dr Mitchell Hutchinson, took it upon himself to raise funds for a new building, but the corporation would only agree to the repair and refurbishment of the existing building. He was so determined, however, that one night in February 1723, Hutchinson secretly brought a team of workmen to the old church and, while Derby slept, demolished the building. Only the sixteenth-century tower was spared. The rest of the church was replaced by a neoclassical structure designed by James Gibbs; the interior described by the architect as '... the more beautiful for having no galleries, which, as well as pews, clog up and spoil the insides of churches'.

During the Second World War, the chain tether of a barrage balloon, which had slipped its mooring during a storm, snagged one of the towers' pinnacles, destroying the top half of the pinnacle.

Since 2005, a nesting pair of peregrine falcons became a major attraction for bird enthusiasts. Over the years, a nesting platform was put in place, and webcams periodically installed so that the progress of the chicks might be observed without any disturbance.

## 12. The Friary (1731)

In the early thirteenth century, black-cloaked monks, with alms bowls hanging from their waists, started appearing in the Market Place. These were in fact Dominican friars who, unlike the secretive monks, were public figures, tending to the sick and preaching in the language of the common people rather than the Latin used by the monks.

Having earned the sobriquet 'Black Friars', and with assistance from Henry III, the friars built a friary on this site just beyond the town walls.

The Reformation and Henry VIII's proclamation that the monarch was now the supreme head of the Church of England, saw the rapid demise of the monasteries in Derby. Thomas Cromwell, 1st Earl of Essex and king's chancellor, himself a powerful and influential advocate of the English Reformation, sent his emissary, Dr John London, to Derby to secure by whatever means a deed of surrender

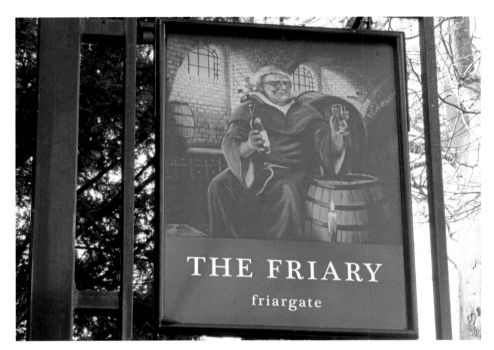

A contemporary sign reflects the Friary's legacy.

The pub/restaurant on Friar Gate today.

from the friary's Prior, Lawrence Sponar. The priory's plate and valuables were subsequently forfeited to the royal treasury. For the first time the friary became a private dwelling, as 'gentleman' John Sharpe took up residence, secured with a twenty-year lease.

The existing Grade II-listed building on the site was built for Samuel Crompton, son of wealthy Derby banker, Abraham Crompton. There is evidence that stones from the original friary were used in the foundations of the new Georgian-style building, now named The Friary House.

Over the next several decades, the house underwent regular alterations and extensions as it changed hands. In 1922, the surviving spouse of Henry Boden sold the house to the Whitaker family who, much to widow Boden's despair, converted the house into a hotel.

The next change of usage came much later in 1996, when it became a public house. Today it is a pub restaurant and nightclub.

## 13. Kedleston Hall (1765)

Since the late thirteenth century, the Kedleston estate has been the country seat of the Curzon family.

In 1759, Tory politician and peer, Sir Nathaniel Curzon undertook an ambitious and costly project to rebuild the family house. Architects James Paine and Matthew Brettingham were commissioned to design the house in a style of classical architecture, adapted by the sixteenth-century Venetian architect Andrea Palladio. The style, now referred to as Palladianism, is characterised by formal Greek and Roman temple architecture, and would therefore meet Curzon's desire to have a 'temple of the arts' that would leave his visitors in abject rapture.

'Temple of the Arts'. The pavilion on the left is still the family home.

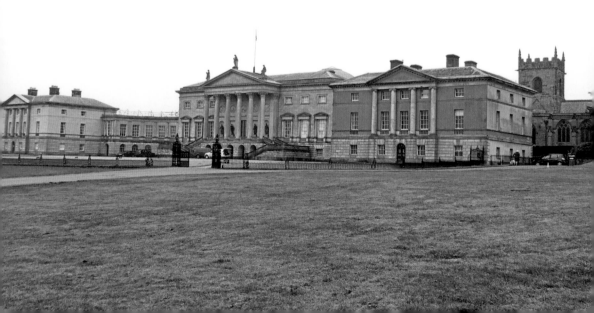

The expansive gardens were to receive the same revamp brief, with architect Robert Adam being tasked to design garden temples to enrich the surrounding gardens and parkland. Adam, who had recently returned from three years study in Italy and who shared Sir Nathaniel's enthusiasm for ancient Rome and the principles of classical design, was then also given responsibility for the completion of the new hall and its interiors. His explicit brief was to produce a palatial, lavishly furnished entertaining hall that displayed Curzon's remarkable collections of pictures and statues. It had to rival the Devonshire's Chatsworth House.

Intended as the unashamed and unapologetic ultimate display of personal wealth, and as the location for grand entertainments, the main house was never meant to be a family home, but a canvas on which to showcase the finest paintings, sculpture and furniture. Like the Phoenix, the grandeur of Rome would rise in Derbyshire.

Over time, the hall was added to, such as the eastern museum, which displays Lord Curzon's collections of objects gathered during his late-Victorian travels in Asia. Part of the West Wing, originally occupied by servants and the kitchens, now houses the offices of the National Trust, custodians of Kedleston Hall today. The East Wing remains the private residence of the Curzon family.

The old formal garden, in vogue in Sir Nathaniel's era, gradually faded away as a more natural landscaped park and recreation ground, influenced by the style of landscaper Capability Brown, was developed. Today, it is difficult to think that the magnificent gardens and surrounds are all man-made, including the lake. Albeit that many of Robert Adams's delightful garden temples and follies no longer exist, the pleasure ground still boasts the 3-mile-long Ladies Walk, which follows much of the original walkway.

The south front, inspired by the Arch of Constantine in Rome.

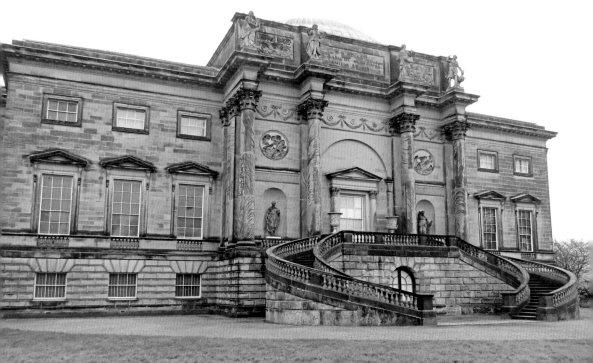

## 14. St Helen's House (1766)

A defining characteristic of England in the Middle Ages was the readiness with which many men and women adopted a life of solitude and Christian devotion in monasteries and nunneries.

In Derby, in the late 1130s, monks of the Order of St Augustine built an oratory dedicated to St Helen. It was for this reason that the future Derby School building, erected on the site, was named St Helen's House.

Building on St Helen's House was completed in 1767 for Alderman John Gisborne of Yoxall Lodge in Staffordshire. It was constructed in the Palladian style from a design by the well-known Derby architect Joseph Pickford. In spite of considerable alterations to the building's internal structure over the ensuing years, the façade remains largely untouched.

In 1801, the engineer and inventor William Strutt FRS, purchased the prestigious building, which he later fitted out in the manner he employed in the new Derby Infirmary, including a one-horse steam engine to power laundry machines, and a hot-air heating system.

Upon William's death, his son Edward inherited the house, and in 1860 the house was offered to the Derby School board of governors for purchase. The Derby Corporation contributed to the purchase, and in January the following year, Derby School moved there from St Peter's Churchyard. In 1872, new rooms

The former school.

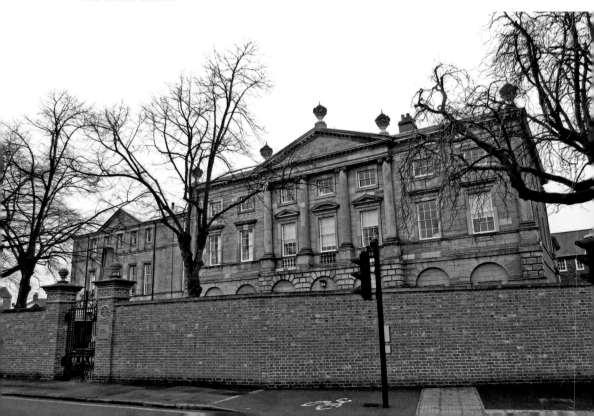

were added, and on a festive day that year the Prince and Princess of Wales opened the extension.

Styled in the Victorian era as a 'public school', the ambitious headmaster, the Revd Walter Clark, cultivated a vision that the Derby boys enrolled at the school would have subsequent enhanced access to the eminent universities of Oxford and Cambridge.

In the 1880s, a red-brick Gothic-style chapel was built to the north of the school yard, affirming the school's fidelity to the Church. It also aligned itself with the nation's military by introducing a cadet corps.

During the Second World War, the school was evacuated and used by the Ordnance Survey department for the production of war maps. With the cessation of hostilities, the school returned, where it stayed until 1966 when it took up new premises in the suburb of Littleover.

For the next six years, the Joseph Wright School of Art occupied St Helen's, after which the building became an adult education centre. In 2004, however, the centre had to be moved because of mounting concern over the deteriorating condition of the house, which then fell vacant.

Derby City Council, unable to pay the enormous costs of repair, sold the house to a property developer in 2006. Planning permission was granted for the conversion of the building into a hotel and the construction of an adjacent apartment complex. After some basic internal refurbishment and weather-proofing

The rapidly deteriorating school chapel.

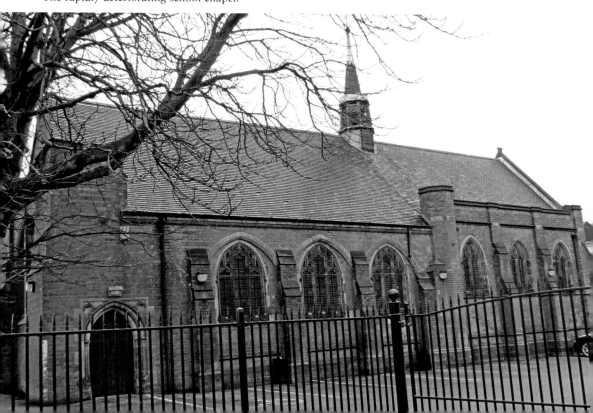

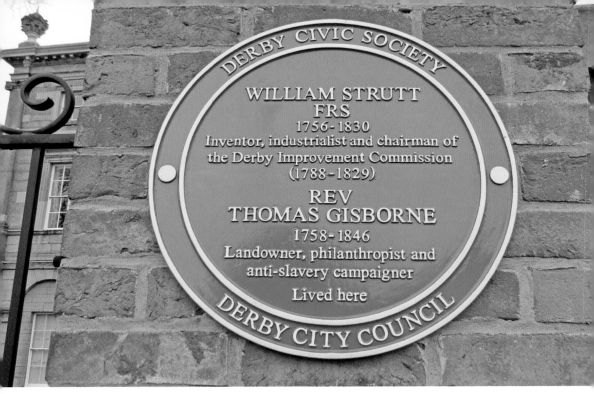

Blue Plaque status.

of the external stone walls, however, unstable economic conditions at the time resulted in the plans being cancelled in 2011.

Essential repair and restoration work was then conducted, and in October 2013 the house received a 'Blue Plaque' to commemorate earlier residents William Strutt and Revd Thomas Gisborne.

A firm of accountants then started renting some of the available office space, but the future of St Helen's with the crumbling period buildings on the site remains uncertain.

## 15. Vernon Gate (1826)

As early as 1327, a Royal decree provided for Derby to have its own jail. Around 200 years would pass, however, before the town constructed its own gallows, capital punishment having hitherto been carried out in nearby Nottingham.

In 1756, the jail in the Corn Market was eventually shut down. It was a notoriously dirty and damp facility, situated on a brook which frequently flooded the jail. In its history, three inmates drowned when their cells became submerged. A new prison was erected at the top of Friar Gate, but its capacity was limited to only twenty-nine prisoners.

All that remains today of the Victorian county jail, is the imposing Vernon Gate façade. Built in 1826 at a cost of £65,000, this was the place of incarceration for

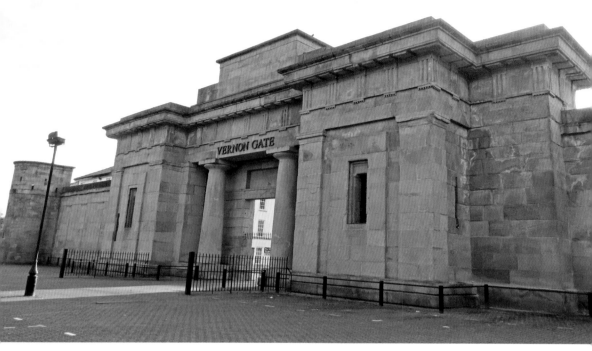

All that remains of the former prison.

those convicted in the Assizes of Shire or County Hall at St Mary's Gate. The walls, however, also held a much darker past, for this was also the place of public execution for those sentenced to death. To the right of the entrance, the scaffold would be erected, and a fresh grave dug and ready to receive the condemned prisoner. The fifteen-minute tolling of the chapel bell alerted and attracted the town's population to the imminent hanging, some having travelled from afar to be there when justice was meted out. The hoisting of a black flag signalled that the execution had been carried out.

When it received its first prisoners in 1827, the 6-acre complex could accommodate 315 inmates.

The Society for the Improvement of Prison Discipline, set up in 1816 to address the deplorable conditions prevalent at the time in most British prisons, lauded the county jail as the best designed and built in the nation.

Eight Martello towers were added in 1831, primarily as defensive positions.

The prison closed in 1919, and for the next ten years, it was used as a military prison. The prison was then demolished, but the imposing stone façade and two Martello towers were preserved.

In a complete change of usage of the site, in 1933 the Derby Greyhound Stadium was constructed, the Vernon Gate becoming the main entrance. This popular betting and entertainment venue eventually closed in 1988, making way for a prestigious housing and office development.

## 16. Royal Crown Derby (1839)

In the seventeenth century, wooden and pewter dishes and drinking vessels were still the norm. With the improved availability in the country of tea and coffee, the consumption of these beverages spread out from London. As a result, plates, teapots, and cups and saucers started becoming domestic items in households.

Derby was a pioneer in the manufacture of porcelain, general referred to as 'china'. In 1750, Derby banker John Heath brought two china-making experts over from France with the intention of making china. Heath then persuaded artist and enameller William Duesbury to give up his employ at the Chelsea china works in London to partner him in his new venture in Derby. Crown Derby was thus born, a manufacturer of top-quality china, and quickly renowned for its exquisite blue-bordered – the colour Duesbury discovered – plates, cups and saucers, decorated with flowers and leaves, and embellished with fine gilding. The quality of the product demanded such high prices, that writer, poet and lexicographer Dr Samuel Johnson was claimed to have said that vessels of silver were cheaper than Derby china.

In 1773, a Royal letters patent granted the china manufacturers entitlement to add the word 'Royal,' to its title. The factory on Nottingham Road continued to expand, and over time ownership changed several times; for example, the purchase of the business in 1811 by employee Robert Bloor for £5,000.

In 1887, Royal Crown Derby moved to its current premises: the former Union Workhouse on Osmaston Road.

Early nineteenth-century Derby was often described as 'drunken and rowdy', and it fell on the churches to try to address the social and economic devastation

The former workhouse now home of internationally acclaimed fine bone china.

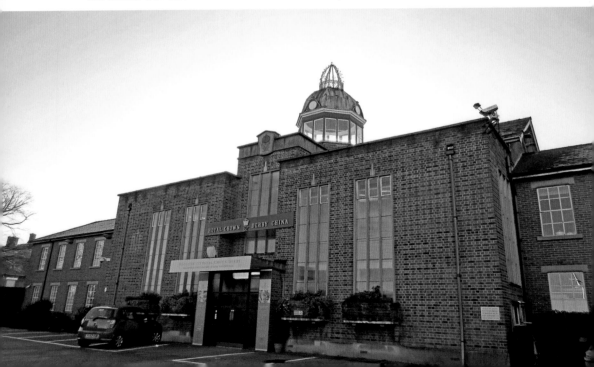

created by an abundance of public houses among the low-income townsfolk. As part of a strategy to come to the aid of such victims, Derby parishes established a Poor Law Union, with a body called the Guardians of the Poor at its head. Albeit the fact that this new body facilitated an easing of the rates levied to finance the activities of the union, in practice, inhumane conditions were imposed on potential beneficiaries seeking assistance: they had to leave their homes and move to a new workhouse built on Osmaston Road. The facility held abject terror for Derby's poor, referring to the building as 'The Bastille'. In 1911 alone, 700 of the town's old and destitute were taken into the workhouse.

In 1964, the Pearson family acquired Royal Crown Derby. A short while later, Royal Doulton was purchased. In 2000, former Royal Doulton director Hugh Gibson led a successful buyout of the company from the Pearsons. In 2013, the world-leading manufacturer of fine ceramic tableware, Steelite International, acquired Royal Crown Derby.

Launched in 1981, Royal Crown Derby's much sought-after range of ceramic paperweight models has enjoyed considerable international success as valued collectible objects.

Royal Crown Derby fine bone china.

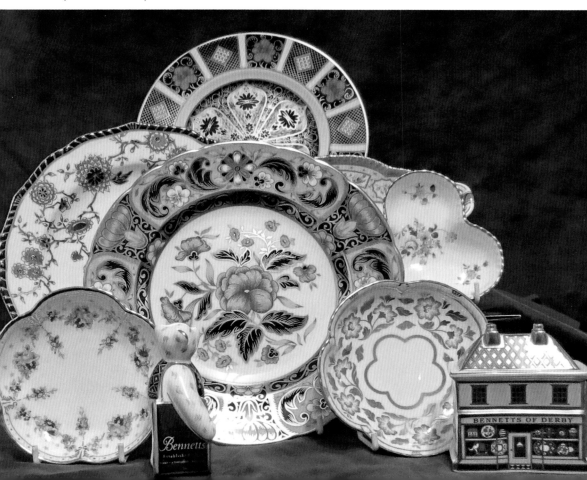

17. Railway Station (1840)

Twelve years after England's first railway came into existence, in 1839 Derbyshire coal owners met in Eastwood on the border with Nottinghamshire to form the North Midland Railway Company. A London-via-Birmingham service was introduced shortly thereafter, an overnight journey of eight and a half hours.

The following year, a relatively passenger-unfriendly station was built, providing a stop for three railways – North Midland, the Midland Counties and the Birmingham & Derby, each with its own workshop. This layout would accommodate the future locomotive works. The station lacked both a central platform and a footbridge, so passengers had to find their way across a level crossing to access the 'top' platform.

Within a year, train services were expanded to include Leeds, Lincoln, Leicester and Bristol, with rails tending to closely follow the ancient Roman roads. Derby's popularity as a rail junction for travellers necessitated the building of the adjacent Midland Hotel.

In 1843, fare-prices competition among the three railways resulted in financial hardships for the companies, prompting the successful recommendation and implementation by railway financier and failed politician, George Hudson – dubbed the Railway King – for a merger into a single railway: the Midland.

During the First World War, recognising the strategic importance of Derby's rail and workshop complex, the Germans sent one of their Zeppelins to bomb

Derby's refurbished main railway station today.

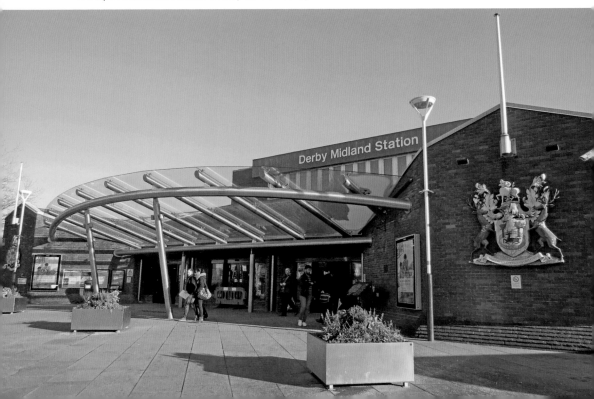

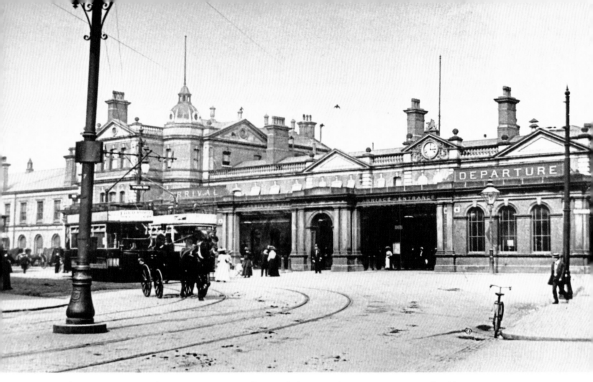

Derby Corporation electric tramcars in front of the grand Victorian station building, *c.* 1910 (photo courtesy of Derby City Council and www.picturethepast.org.uk).

the area. Only minor damage was sustained. In January 1941, the German Luftwaffe struck again, but this time their bombers inflicted considerable damage to the railway hub. Platform 6 was badly damaged and a train shed had its roof destroyed. The façade of the station, however, escaped unscathed.

In 1950, the station was given the name it has to this day – Derby Midland Station, even though only the word Derby is used on timetables and platform signage.

The Victorian entrance to the station was replaced in 1985 and the ticket hall modernised. The decorative dragon-encircled station clock, together with its supporting structure was moved to the end of the north carpark.

More recently, a modern glass and chrome canopy was erected at the station entrance, and the front redesigned to better accommodate public transport.

18. Roundhouse (1840)

Robert Stephenson, son of railway pioneer and engineer, George Stephenson of the 'Rocket' fame, built this Grade II-listed building in 1839. Not only was it the first ever railway 'roundhouse', but it remains today, faithfully preserved, as the oldest surviving of its type in the world. The project was a joint venture made up of North Midland Railway, the Midland Counties Railway, and the Birmingham and Derby Railway.

The sixteen-sided building comprises a 12-metre central turntable, from which radiates sixteen tracks to receive and line-up steam engines and rolling stock into various booths for maintenance and repair.

Two ancillary buildings were erected adjoining the Roundhouse – a carriage shop and a three-storey office block. A freestanding engine shop went up to the north of the complex.

The last steam engine repair at the facility was carried out 1963, after which it was used for work on diesel locomotives until its closure in 1988.

In 2008, at a cost of £48 million, the Roundhouse and its associated buildings were skilfully repaired. The work was conducted in a process adhering to the philosophy of William Morris – founder in 1877 of the Society for the Protection of Ancient Buildings – that dictates that old buildings should only be repaired in a way that remains wholly true to its original structure and appearance.

When the consulting engineers moved on site to assess the Roundhouse roof, they were astounded that the cast-iron and timber roof had not already collapsed. Decades of water damage had resulted in more than half of the roof's primary supporting trusses being on the point of collapse. Core samples were carefully taken from every piece of structural timber and analysed. The results not only revealed significant decay, but also the fact that, in many cases, the timber used in the original construction was of inferior quality.

Keeping in tune with Morris's ethos of repair, wherever possible, relatively sound beams were strengthened with steel plates. In other cases, rotten timber was cut out, and new lengths of European redwood – the original timber – spliced into the gap.

Today, part of the Derby College campus.

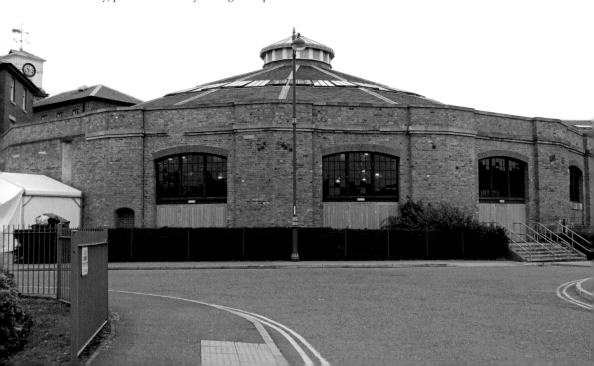

With the addition of two new buildings, Derby College took over the historic complex, establishing on the new campus academies for study in the field of engineering, construction and the motor vehicle industry.

The turntable still exists in the Roundhouse, the building now a multi-purpose functions venue with a seating capacity in excess of 650.

## 19. The Arboretum (1840)

In September 1840, Derby entered the record books as having the first publicly run park in Britain. Designed by leading garden planner, John Loudon, textile magnate Joseph Strutt had donated eleven acres of his private land and £10,000 for the landscaping of the arboretum.

A dedicated social reformer, Strutt had a strong empathy with the town's working class, believing that they were equally entitled as the wealthy were to a place of recreation and entertainment to detract from the miseries of a menial existence. At the age of twenty-eight, the determined Strutt took on civic office, and in his time of service, was twice elected mayor.

The Arboretum would be his greatest legacy, as even after his death in 1843, the park and its associated entertainment drew people on day excursions from as far away as Sheffield and Birmingham. In July 1846, the local newspaper reported that attendance had peaked at a record 15,000, of which more than 5,000 had come by train.

Towards the Rosehill Street edge of the park, a glass structure was erected, which in appearance, was not unlike the Crystal Palace that went up in Hyde Park

Joseph Strutt gazes down on visitors at the entrance to the park.

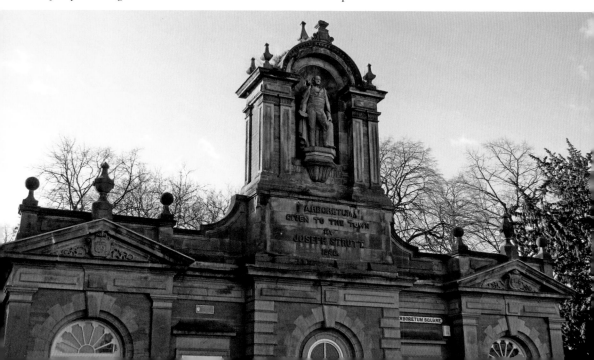

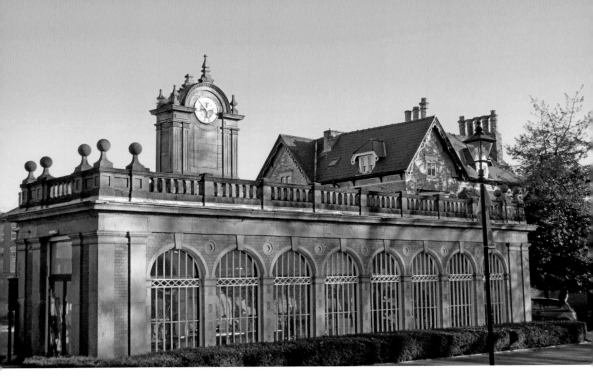

The clock tower from inside the Arboretum.

in London six years later – ironically, the Derby structure was called 'The Crystal Palace'.

The Arboretum's grandeur peaked in 1853, when a large stone and wrought-iron main entrance, complete with clock tower, was built. A romanticised statue of Strutt looks down on the splendour with which he had generously given Derby.

Sadly, mismanagement, and the fact that for five days a week Derby residents had to pay an entrance fee, resulted in a steady decline in its beauty and what it had to offer the visitor. By 1878, many of the plants originally cultivated to facilitate botanical research had died of neglect, and were not being replaced. Smoke and other toxic gas emissions from the town's foundries and pottery kilns were major contributing factors that led to the demise of the showcase park.

## 20. Derby City Church (Temperance Hall) (1853)

An 1852 edition of *The Builder* carried this article on the Temperance Hall:

> The ceremonial stone of this building was laid on the 3rd inst. by Lawrence Heyworth, esq. M.P. for Derby … It was designed by Mr. H.J. Stevens, and will be erected by Messrs. Bradbury and Humphreys, contractors.

It is described as a two-storey building, comprising a lecture room, club room, reading room, ante-room and a kitchen. Four turret staircases provide access to

the hall and cantilevered galleries, with a seating capacity of 1,000–1,500. The estimated cost was given as being '… upwards of £2,400'.

The Temperance Movement began in the 1820s as a social movement against the consumption of all types of alcohol. The movement vociferously abhorred excessive alcohol consumption, while promoting complete abstinence – teetotalism – and lobbying government to introduce legislation to regulate the production and sale of alcohol, or even its total prohibition.

During Victoria's reign, the movement stepped up its campaign, no longer even tolerant of moderate consumption. A call was made for national legal prohibition, now suggesting that imbibing any amount of alcohol was leading to religious revivalism and immoderate politics, such as female suffrage.

By the middle of the century, particular attention was increasingly being given to the harmful effects that alcohol was having on the life and health of working-class children. At its peak, the movement organised rallies and demonstrations to persuade townspeople to pledge total abstinence.

The former Temperance Hall building still seems to provide a venue similar to that for which it was originally built.

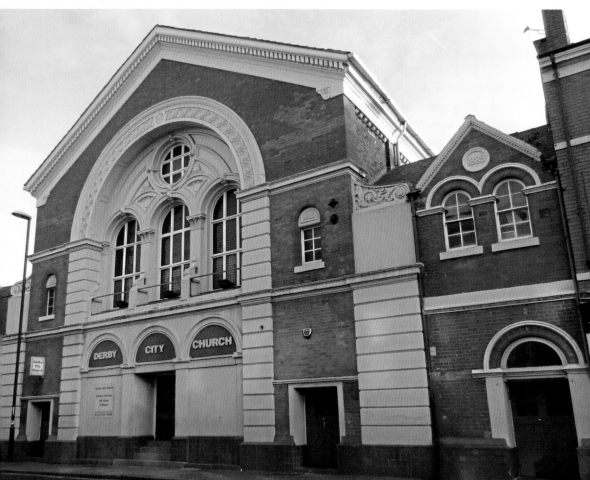

Internationally, the social and political phenomenon that was the Temperance Movement, started to wane in the 1930s, with prohibition being given as a major cause of misinterpreting the effects of social drinking, promoting criminal activity, and restricting commercial enterprise. That same decade witnessed a gradual easing of licensing laws in the United States.

By this time, however, the Derby Temperance Hall was no longer being used for the purpose for which it was originally built. As early as 1904, the building had become the town's first film venue with regular screenings every Saturday night. This continued until the first bespoke cinema in Derby, The Midland Electric, was built.

The hall then became the headquarters of the Derby Conservative Association, and by the 1950s, had been converted into a dance hall, known as The Churchill.

Soon thereafter, the Elim Pentecostal Church took over the Grade II-listed building, calling it the Derby City Church. This evangelical Christian group still occupies the building, even though they almost sold it to JD Wetherspoon pubs in 2008.

## 21. Corn Exchange (1861)

The farming and marketing of corn always featured prominently in Derby's economic past. During the reign of Henry VII, the trade in this commodity had become so large, that the Crown introduced yardsticks and bushel measures to regulate the trade. With this expansion, a specific corn market was opened.

By 1880, however, local farms were no longer able to sustain the town's demand for wheat and flour, resulting in the railways having to be used to transport in wheat from beyond the region to satisfy needs. The outcome of this was the closure of the Corn Exchange.

In 1897, the building became the Palace Theatre of Varieties, with external signage boasting of 'twice nightly' dances. The venue hosted special nights every Friday, where evening dress was a prerequisite for patrons.

The outbreak of the First World War forced the dance hall to shut its doors for the last time. In 1919, the guns now silent across Europe and civilian life starting to recover to a semblance of pre-war normality, the Palais de Danse took over the vacant premises. In addition to fine, upmarket tearooms, dining salons and lounges, the new owners offered its clientele an opulent – almost decadent – dance hall; the interior was finished off in an art deco style which luxuriously surpassed any previous usage that the building had ever seen. Exorbitant admission charges were way beyond what Derby's man in the street could ever afford.

Ten years later, the *Derby Evening Telegraph* replaced the occupants, setting up its offices in the building.

Since then, the building was occupied by the Corn Exchange Sports Bar which, in addition to being a licensed bar, became a major tournament venue for Derwent Valley Pool League and the Derby Indoor Sports Association.

At the time of writing, a recruitment firm occupies the building.

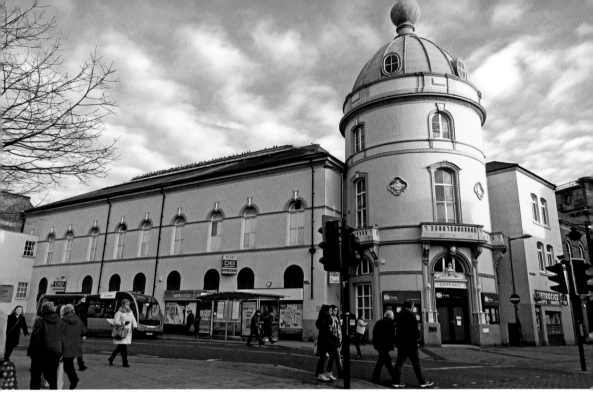

The Corn Exchange building facing Albert Street.

## 22. Guild Hall (1842)

Being desirous of having the same civic rights and liberties enjoyed by neighbouring Nottingham by royal charter, the men of Derby paid King John for their own charter. One of the provisions of the charter of 1204, was the authority to establish a Merchant Guild, which included a cloth-dyeing monopoly within 15 miles from the town. The guild was responsible for securing fair prices and safeguard employment. It incorporated trading in textiles, leather goods, metalwork, wholesalers and retailers, builders and farmers.

At the time, the guild's authority was absolute and rigorously enforced. Typically, wool would arrive in the market place, where a member of the Guild would place his foot on it, thereby symbolically proclaiming that the stranger may only sell his product to a member of the guild.

A guild hall was first mentioned around 1555 during the reign of Henry VI. The plaster and wood, two-storey building stood in the market place. The lower floor also housed a two-celled jail. Town council meetings, the borough court and assizes were held in a room above.

In 1730, the medieval Guild Hall, which had also been the venue for the election of MPs, was pulled down to make way for a new stone building.

In 1828, the Guild Hall moved from the market place to a new building on the south side of the square. Eight years later, following disturbances in the poorly

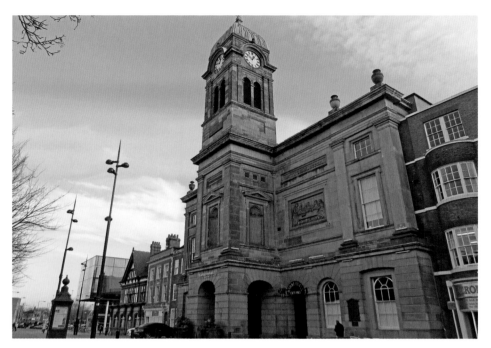

The Guild Hall clock tower and original coach entrance.

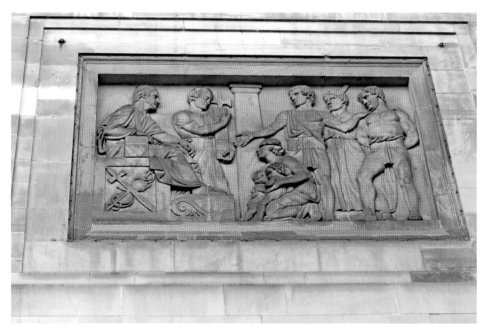

One of the external friezes identifying the premises where justice is served. The individual standing next to the seated magistrate holds the fasces, the Roman symbol of a magistrate's jurisdiction and power.

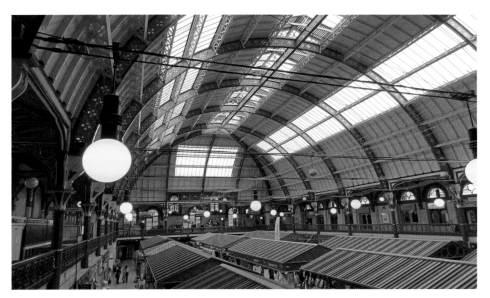

The Market Hall interior restored to its Victorian splendour.

lit council chamber, the decision was made to light the Guild Hall with gas. The life of the new building was short-lived, however, when a fire in 1841 could not be contained with the inadequate town council firefighting methods, causing substantial damage to the building.

The present Guild Hall, with its clock tower, was then built, the interior and the façade the design work of Duesbury & Lee. The coach-access archway was retained, leading to the market hall via a cobbled way. In 1863, the town council built the covered market hall adjacent to the Guild Hall.

Romanesque carved stone panels flanking the clock tower depict the municipal and judicial uses of the hall, functions for which it had originally been built.

Standing in the market place, facing the Guild Hall, is the poignant First World War Memorial, unveiled on 11 November 1924. Sculptor George Walker's bronze statue of a woman holding a baby in her arms – many take this to be the Virgin Mary and baby Jesus – fronts a large stone Celtic cross. A later epitaph was inscribed on the memorial as a tribute to the men of Derby who lost their lives in the Second World War.

## 23. Bombardier (Derby Works) (1876)

Railway will supersede almost all other methods of conveyance in this country – when mail coaches will go, railway and railroads will become the great highway for the King and all his subjects.

George Stephenson, *c.* 1840

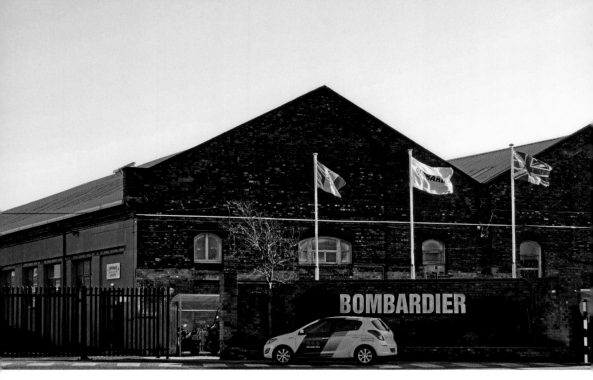

The main entrance to Bombardier has changed little over the years.

The erection in 1840 of three railway maintenance sheds behind the railway station, which included the Roundhouse, was the catalyst for a rapid expansion into what became the Midland Railway Locomotive Works, known simply as 'The Loco'. As the enterprise grew, it became necessary to split locomotive production and maintenance from that of carriages and other rolling stock. The new facility, established in 1876, was situated on Litchurch Lane, and titled the Derby Carriage and Wagon Works.

The first carriage manufacturing, still at the original locomotive works, commenced in 1873 using kits provided by the Pullman Co. of Detroit in America. These carriages were followed by local carriage-designer Thomas Clayton's own design of a 54-foot-long coach, which incorporated both first- and third-class accommodation, and ran on four- or six-wheeled bogies. By 1883, these carriages sported the characteristic crimson livery. By 1903, Clayton's successor, David Bain, was also overseeing the production of sleeper coaches and dining cars.

The First World War saw the works redirecting its resources to producing supplies for the army, including the manufacture of ambulance trains and army wagons, in addition to parts for combat rifles.

From 1923, and for the next six years, the so-called 'corridor coach' was manufactured, which featured individually doored compartments. This popular coach remained in use until the early 1960s.

During the Second World War, the loco works incorporated the repair of aircraft wings, including those from Hampden and Lancaster bombers.

With nationalisation in 1948, the Litchurch Lane works became British Rail's regional centre for coach and wagon production. Diesel Multiple Unit (DMU) cars were first introduced in 1953: a carriage where a passenger unit is powered by an on-board engine.

In 1969, the works were transferred to new subsidiary British Rail Engineering Ltd (BREL), and renamed Derby Litchurch Lane Works. Wagon building and repairs ended, with a major reorganisation of the carriage and railcar work, and in 1979 container production ended.

British Rail was now coming under increasing financial pressure to close branch lines throughout the nation, and by 1984, a worldwide demand for a low-cost rail vehicle was developing. This resulted in the Research Division and British Leyland together producing a lightweight four-wheeled vehicle, named the LEV-1.

BREL was privatised in 1989, becoming a wholly owned subsidiary of the Swiss-based multinational Asea Brown Boveri (ABB) in 1992. Four years later, the works became part of ABB Daimler-Benz Transportation, under the brand name Adtranz. In 2001, the Canadian firm, Bombardier Inc. acquired the business.

Known today as Bombardier Rail Vehicles Production Site, the 338,000-square-metre facility on Litchurch Lane has production contracts for the supply of Turbostar DMUs to Anglia Railways, Central Trains, Chiltern Railways, Hull Trains, Midland Mainline, ScotRail, South West Trains, London Midland, London Overground Rail Operations Ltd. In addition, the site also manufactures, under contract, Electrostar electric multiple units for the Gautrain Rapid Rail Link in Johannesburg, South Africa, and Capitalstar electric multiple units for Transport for London Metros for London Underground.

Bombardier celebrates its association with Derby's long history in the nation's rail industry.

## 24. Library and Museum (1879)

The English Reformation introduced an element of spiritual enlightenment where Protestants yearned to read the contents of the Bible for themselves. While the printing process had made books relatively plentiful, they were beyond the reach of the ordinary citizen. Recognising this, and following general practice at the time, All Saints Church introduced a reading desk at which people could come and read the Bible and other religious books. Such tomes were chained to the desk to deter pilfering. This came to be Derby's first public library.

In the early 1800s, Derby educationist John Pratt addressed a growing demand for adult literacy by starting affordable night classes at which workers could learn writing and arithmetic. Soon thereafter, printer George Wilkins established a lending library in his sitting room in Queen Street. This became known as the Derby Town and County Library.

Michael Thomas Bass (1799–1884), Liberal Party MP for Derby, was a very wealthy philanthropist who owed his success to his internationally acclaimed Bass Brewery. Bass used his seat in the House of Commons to champion the cause of beer brewing in the Midlands. His legacy would be assured as a leading benefactor of Derby, his personal funding of a school of art, swimming baths, recreation grounds, and a new library and museum providing lasting testimony to his munificence.

The European-styled clock tower above the library's main entrance.

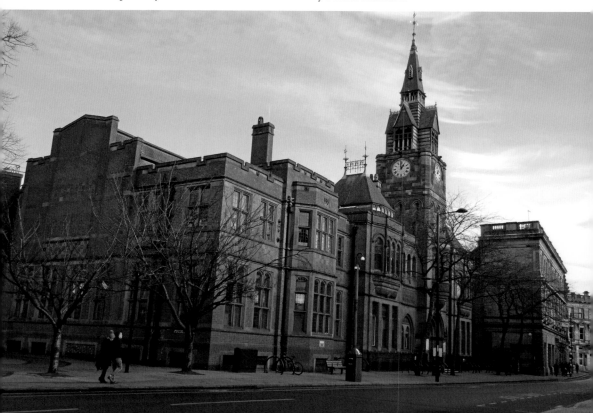

In 1879, this generosity allowed for the construction of a combined free library and museum. The result was a magnificent Flemish-Gothic red stone and brick building, with a spired clock tower. An adjacent art gallery followed shortly thereafter.

The new library housed the Devonshire collection as well as the contents of the Permanent Library and Philosophical Society. By late 1898, almost 20,000 books were available for lending to the public.

In 1914, the curator's house next to the library was flattened to make way for an extension to house the recently acquired Bemrose Library, formerly owned by Sir Henry Howe Bemrose. Money for the purchase of the collection had been raised from the public.

At the death in 1945 of Derby art collector Alfred E. Goodey, £13,000 was bequeathed to build an extension to the museum. It was only in 1964, however, that all work relating to the extension was completed and the museum moved. Part of the original nineteenth-century building is still shared between the library and the museum.

Refurbishment to sections of both the new and old buildings was carried out in 2010–11.

## 25. Standing Order Pub (1880)

Situated in Derby's Cathedral Quarter, this palazzo-style building was constructed by J. A. Chatwin, three years after Derby banker Samuel Crompton and wealthy cotton merchant Thomas Evans merged to form the Crompton and Evans Union Bank in 1877. The Old Talbot Inn that stood on the site was demolished to make way for the bank building.

Abraham Crompton had established Derby's first bank in the second half of the seventeenth century, becoming a prosperous and much-respected financial institution.

By the outbreak of the First World War, the bank had grown to include forty-six branches and sub-branches, with deposits nearing £6 million. In 1914, as part of an aggressive, national acquisition programme, the London-based Parr's Banking Co. purchased the Crompton and Evans bank. At the end of the war, the bank amalgamated with the London County and Westminster Bank, which now embarked on establishing foreign banks on the Continent.

The banking fraternity were stunned when, in the late 1960s, this already powerful banking group merged with another financial powerhouse, National Westminster. In 1970, this new banking giant, now commonly known as NatWest, opened its doors, retaining tenancy of the Iron Gate building until 1994.

A pub, appropriately called 'The Standing Order', then took up occupancy of the Grade II-listed building with the owners JD Wetherspoon preserving the plush interior walls and vaulted roof befitting the age of the building. A visiting guest said of the pub, 'This must be the grandest Wetherspoon's in the country.'

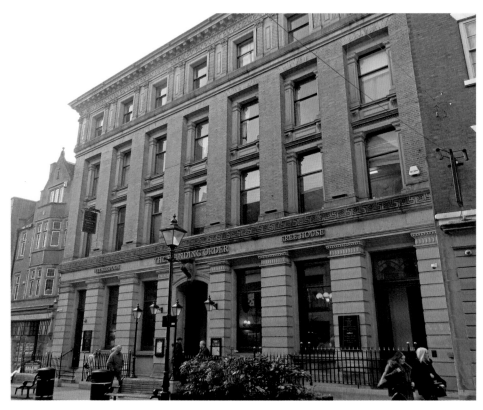

The Standing Order pub's name honours the building's banking history.

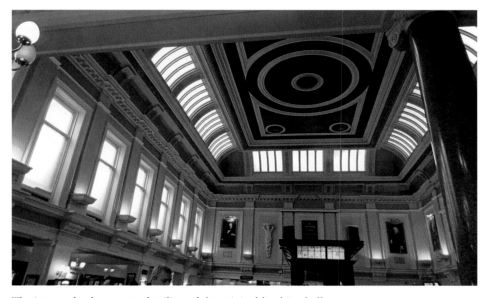

The immaculately preserved ceiling of the original banking hall.

## 26. Derby Gas Light and Coke Company (1889)

This Grade II-listed building is an early example of steel-framed Victorian architecture. With its brick frieze reading 'Derby Gas Light and Coke Co' in raised lettering, it stands in contrast with the Georgian buildings in Friar Gate. The façade appears to struggle to find its identity – a veritable concoction of windows and gables, with a lack of symmetry. The building housed the company offices and showrooms, before later moving to larger premises.

At the instigation of the local council, and in response to public demand, the Derby Gas Light and Coke Company (GLCC) was formed and incorporated by an Act of Parliament on 22 June 1820. The works were situated at Cavendish Street, and in 1841, the Derby Gas Act extended the area of supply. Seven years later, in response to the emergence of a competitor, the Derby GLCC underwent restructuring, setting up a central office on Victoria Street.

Through the Derby Gas Act of 1852, the area of supply was extended to include the suburbs of Littleover, Chaddesden, Normanton and Peartree. Around 1860, new works were planned at Litchurch, but this was on land required by the LMS Railway Company for the extension of their line from Derby to Osmaston. An agreement was subsequently reached for the exchange of lands, allowing for the building of a much larger gas works. The Litchurch works were considerably

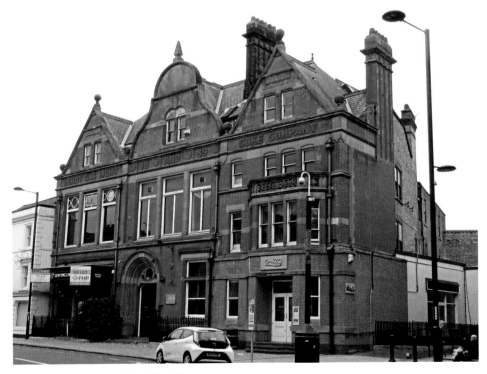

The largely vacant red-brick building.

larger than those at Cavendish Street, and became the company's principal site. In 1915, to meet an increased demand brought on by the war, a new 'B' works was built on the same site across the canal.

In 1902, the company acquired the Duffield, Quarndon and Allestree Gas Co., and the following year, extended the supply limits to include Chellaston, Alvaston and Aston-on-Trent. With the acquisition of more and more satellite gas companies, all surrounding works – except at Belper – were closed down. By 1932 Derby was being fed off the national grid, and the Litchurch works were used to supply peak demand only.

During the Second World War, the Litchurch works were brought back into production to meet increased demand, and extensions to the works carried out after nationalisation.

Since 1979, the building has been converted into nightclubs and bars. With the recent completion of the new bus station and hotel complex in 2010, Genting Casino vacated the left part of the building, which now stands vacant. The other part of the building houses the Okra fine-dining Indian restaurant.

## 27. Derbyshire Royal Infirmary (1891)

As Derby prospered, the eighteenth and nineteenth centuries witnessed a substantial increase in the number of wealthy citizens, as industry and trade flourished. For many members of this upper-class gentry, the price to pay for this new-found lifestyle was a rise in health issues, such as the fashionable eighteenth-century indicator of opulence: gout. It was, therefore, equally in vogue for sufferers of this social malady to take the waters in the mineral spas of nearby Matlock and Buxton. 'Healing' spring water was also pedalled in the town's streets.

In 1810, the civil engineer, inventor and architect, William Strutt FRS, designed the Derbyshire Infirmary, which would have a separate wing for the isolation of infectious diseases. When the building work was completed, the ingenious Strutt developed several previously unheard of labour-saving devices, such as a washing machine, a steam hotplate, water closets with continuously pumped water flowing through them and, later on, gaslights.

Not only was the infirmary a showcase, but its contribution to improved health in the town was immense. Built on land that was formerly part of Derby's Castlefield estate, the Derby Royal Infirmary (DRI) would serve the local area until 2009, at which time almost all of the services were transferred to the new Royal Derby 'Super' Hospital. The ancillary buildings, added over many decades, had created a maze of structures and buildings incompatible in design and architectural style.

In 1890, there had been an outbreak of typhoid fever at the infirmary. A major killer in Victorian times, the bacterial disease was transmitted by the consumption of food or water contaminated with faecal matter from an infected person. A three-day official inspection of the hospital resulted in the old building being condemned.

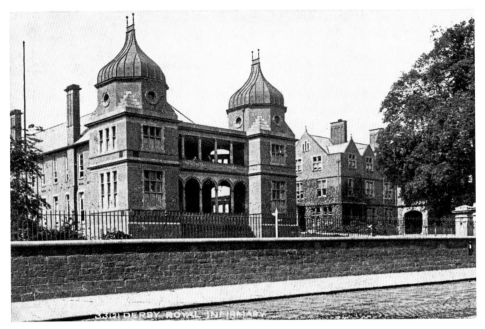

During a visit in May 1891, Queen Victoria laid the foundation stone and bestowed the title 'Royal' on the hospital, *c.* 1900 (photo courtesy Derby City Council and www.picturethepast. org.uk).

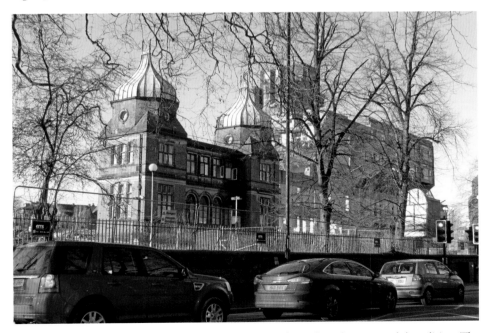

Today, only the two twin-towered façades of the original DRI have been spared demolition. The concrete structure to the right is also being levelled.

During his 1890–91 period in office as mayor of Derby, engineer Alfred Seale Haslam succeeded in replacing the old William Strutt infirmary with the Derbyshire Royal Infirmary. On the occasion of Queen Victoria opening the new hospital on 21 May 1891, she knighted Alfred Haslam for his services to the town. She also granted permission for the term 'Royal' to be used in the hospital's title.

The DRI served the city well, with the addition of a plethora of brick or concrete buildings to house extra wards and an accident and emergency facility. With the progress of time, however, some of the old vacant buildings on the site had fallen into a state of disrepair, while others, such as that which housed the physiotherapy department, were no longer fit for purpose.

The construction of a brand-new super hospital in the city heralded the end of an era for the DRI, and the demolition of what was arguably Derby's most historic and iconic buildings commenced. A new housing development is earmarked for the now empty site. All that now remains are the much newer brick buildings, now titled the London Road Community Hospital.

The London Road Community Hospital is part of Derby Teaching Hospitals NHS Foundation Trust. It provides rehabilitation and intermediate care, inpatient facilities and some outpatient services, such as a walk-in clinic and blood tests. The hospital, although no longer offering an accident and emergency service, still boasts over sixty departments and 700 staff, treating 184,000 patients annually.

There are two statues of famous people along the London Road side of the site. One is of Queen Victoria, which has stood here since 1925 after it had been moved from its original position at The Spot where it had been erected in 1906

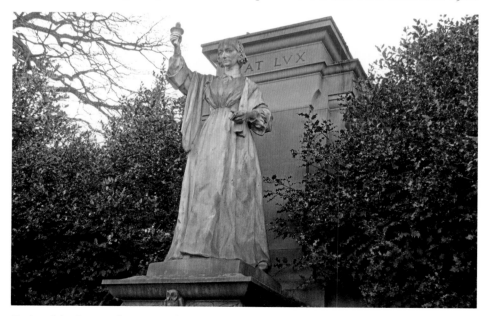

'Lady of the Lamp' Florence Nightingale, maintains a vigil at the site of where the DRI once stood.

and unveiled by her son Edward VII. The other statue is that of the famous nurse, Florence Nightingale, the nineteenth-century 'Lady of the Lamp,' who spent much of her childhood in the Derbyshire village of Lea. The statue stands as a tribute to the founder of modern nursing, whose ground-breaking application of hygiene and treatment of the wounded during the Crimean War became the standard for patient care across the globe.

## 28. Old Boots Building (1912)

On the corner of St Peter's Street and East Street in Derby's city centre, stands the attractive Old Boots Building.

Built in 1912 from a design in the Arts and Crafts style by Albert Nelson Bromley of Nottingham, the appealing chocolate and off-white façade features four small statues in niches above the shop frontage. Architect Percy Richard Morley Horder created the statues using decorative or waterproofing plastering, a method called pargeting, which is particularly associated with the English counties of Suffolk and Essex.

One is of the famous nurse Florence Nightingale, whose revolutionary medical care practices during the Crimean War have been applied since. Another statue is of John Lombe, wealthy Derby silk spinner whose family established the Silk Mill on the Derwent. A third statue is of Derby-born poet and historian William Hutton, who published *History of Derby* in 1791. The last statue is of hosier and spinner Jedidiah Strutt who, in partnership with his brother-in-law William Woollat, developed the production of ribbed stockings using their own 'Derby Rib' machine.

Leaded windows and four statues characterise the façade.

Built specifically for Boots the Chemists, the building represented another in a chain of more than 500 nationwide outlets developed by Jesse Boot, 1st Baron of Trent, of Nottingham. Founded by his father, John Boot, Jesse transformed the tiny herbalist shop in Nottingham into a national retailer, the chain labelling itself 'Chemists to the Nation'. Knighted in 1909, Jesse sold his controlling interest to American investors in 1920.

The Halifax Building Society acquired the building in 1975, and still occupies the banking hall facing East Street. More recently, the international beverage group, Costa Coffee, refurbished and converted adjoining shops into a coffee house.

## 29. Rolls-Royce, Nightingale Road (1912)

The union of innovative minds in 1906 between Charles Stewart Rolls and Frederick Henry Royce would become immortalised in the RR monogram trademark, an enduring symbol of quality motor cars and aircraft engines.

Soon after the company was formed Rolls-Royce moved from Manchester, where Rolls had produced his first car in 1904, to new premises in Derby. Here the sprawling Nightingale Road complex was established, fronted by the unassuming double-storey commercial block – Marble Hall. The company immediately cemented its place in the annals of motoring history with the production of the most successful car ever: the 40/50-horsepower Rolls-Royce Silver Ghost.

Charles Rolls, for many years a keen aviator, stood alone in his foresight of the future of aviation. A fatal air crash at Bournemouth on 2 July 1910, however, abruptly ended any further contribution he may have made.

The First World War forced Rolls-Royce to suspend motorcar production, plunging the company into near bankruptcy. The diversion of energies and resources into producing armoured cars, powered by the same 40/50-horsepower engine of the Silver Ghost, saved the day.

The company board remained resolute in its decision not to undertake aero-engine production, but Royce's longstanding ally, Claude Johnson, was not prepared to idly stand by and watch bankers foreclose on Rolls-Royce. In a calculated move, Royce and Johnson went behind the board's back, going directly to the War Office to offer them their assistance. The licensed production of fifty Renault V-8 aero-engines was the outcome.

Royce then set about designing a V-12 aero-engine: the Eagle. By the end of hostilities, more than 3,000 had been produced, in addition to Hawks and Falcons, thereby saving Roll Royce.

While motorcar production resumed at Nightingale Road after the war, Rolls-Royce was also determined to sustain its new role in the aero-engine business.

The mid-1920s witnessed a radical departure in aero-engine design, as Rolls-Royce developed a twin-bank of six-cylinder engines, crafted entirely from a single block of aluminium. Named the Kestrel, it proved a success, powering RAF fighters in the late 1920s and early 1930s.

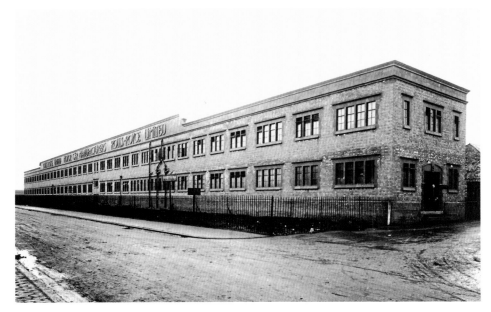

Foundation of a global empire: Marble Hall, known to all as 'Nightingale Road' (© photo courtesy Rolls-Royce Heritage Trust, Derby).

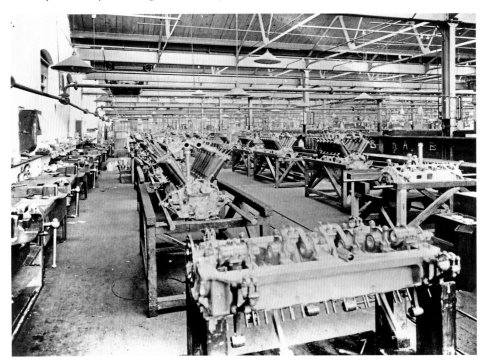

Eagle aero-engine production at Nightingale Road during the First World War (© photo courtesy Rolls-Royce Heritage Trust, Derby).

At this time, Rolls-Royce set out to win the prestigious Schneider Trophy, an annual seaplane race. Aeronautical engineer Reginald Mitchell teamed up with Rolls-Royce in a partnership that would see Mitchell's Supermarine seaplane, powered by Rolls-Royce's 'R' engine, win the coveted trophy three times.

In 1933, the seventy-year-old Sir Henry Royce agreed to the development of a smaller aero-engine, based on the Kestrel engine, which would meet the military's requirements. The result was the designated PV12 Merlin.

Air Marshal Sir Hugh Dowding's successful lobby for government approval for the production of a modern day/night fighter, resulted in the birth of the stalwarts of the Battle of Britain – the Spitfire and the Hurricane. The commencement of wartime production of aero-engines at Nightingale Road saw employee numbers grow to 20,000.

The next landmark event was the introduction of the enhanced Rolls-Royce Griffon engine, developed from the 'R' engine, fitted to subsequent Spitfires for improved performance.

In 1946, motorcar production moved to Crewe. It was thus with a substantial degree of tragic irony that Nightingale Road found itself catapulted into becoming a world leader in aero-engine technology and production. This newfound status, largely arising out of the immense pressure imposed on British innovation to stay one step ahead of Nazi Germany in the arms race, stood the company in very good stead to be a front runner in the development of the jet engine.

The ground-breaking design of the Merlin aero-engine saved Britain in 1940.

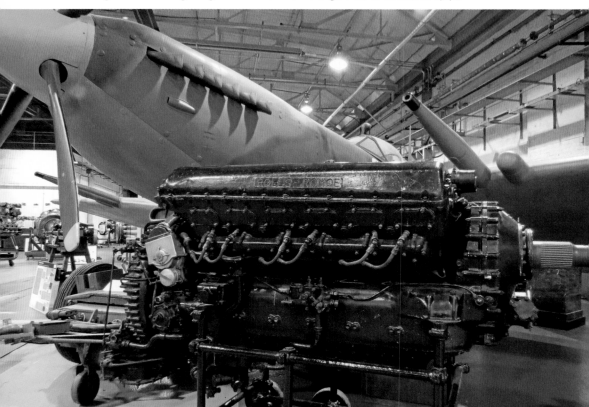

There had already been significant progress in the design of a jet engine in the 1930s, with a Cambridge graduate by the name of Frank Whittle far ahead of the rest in understanding the principles of supersonic airflow. British Thomson-Houston, already allied with Rolls-Royce in the development of engine-driven superchargers, started working with Whittle, and in May 1941, the jet-powered Gloster aircraft passed its test flight with flying colours.

Whittle's sharp criticism of Rover's tardy production of his jet engine eventually came to a head when Rolls-Royce went directly to Rover to see why the production of Whittle's engine was so slow. A deal between the two companies ensued – Rover would relinquish its jet-engine production to Rolls-Royce, in return for the latter's Meteor tank engine. Production of the jet engine started at Barnoldswick in Lancashire, with Nightingale Road providing the design work.

In a highly questionable move, Rolls-Royce engine technology was shared with both the Americans and the Russians. Subsequent to this, in the post-war period, the British government initiated the sale of jet engines to the Soviet Union. In spite of Rolls-Royce refusing to allow Russian visitors into its factories, the Soviets successfully emulated the Rolls-Royce engines, fitting them into the very MiG-15 and MiG-17 jet aircraft that they used against the Allies in Korea.

In 1952, the world's first passenger jet airliner went into service, powered by four Avon 503 engines, the engine developed for Canberra and Valiant bombers. This made Rolls-Royce a pioneer in the field of civil aviation, while securing a place in the lucrative jet-airline market well into the twenty-first century.

In 1966, Rolls-Royce acquired Bristol Siddeley, its only competitor. Both companies had already worked on designs for vertical take-off strike-aircraft engines, only to have government scrap the programmes. Fortunately, during this period of uncertainty, Rolls-Royce kept pace with the development of military engines through its cooperation with French and American aero-industries.

The development and introduction of long-haul passenger airlines in the late 1950s injected fierce competition into the aviation industry, as Boeing and Douglas vied with Rolls-Royce in the market place for their respective protégés: the Boeing 707 and the DC-8. This provided Rolls-Royce with an opportunity to challenge American aero-engine manufacturer Pratt & Whitney's domination of the international market.

Trans-Canada Airlines (TCA) and the British Overseas Airways Corporation (BOAC) ordered the new Boeing 707, and while TCA opted for Rolls-Royce's new Conway engine, it came as a bit of a surprise that the manufacturer in Seattle elected to also install the Conway, even though BOAC had intimated that they would prefer the rival Pratt & Whitney product.

After having lost its bid to provide RB211 engines for Boeing's new 747, the granting of a contract by Lockheed for Rolls-Royce to supply engines for ninety-four of its new Tristar airliners, was deemed a major coup – the whole of Derby celebrated. The elation, however, was short lived. The RB211 failed the critical bird ingestion test, in which its Hyfil blades disintegrated when a bird strike was simulated. Rolls-Royce now faced financial ruin. Millions had been pumped into

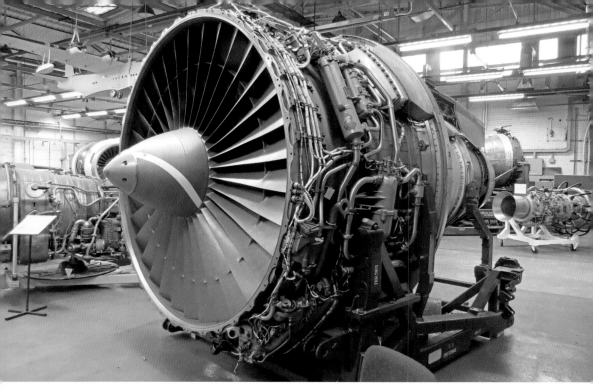

The RB211-22B turbofan engine.

RB211 development. After refusing to run the risk of injecting further capital into the programme, the government called in the receiver in February 1971.

The news reverberated through a stunned Derby. Many lost their jobs with Rolls-Royce, even those with many years' loyal service. In May that year, government secured a new contract with Lockheed, based on the assurance that titanium was now being used to manufacture the engine blades. A new company, Rolls-Royce (1971) Ltd was registered, and all assets transferred to government.

Rolls-Royce managed to survive the economic slump of the 1980s by continuing to supply engines to overseas and local military aircraft manufacturers. With the development of the Trent 800 aero-engine, in the 1990s, British Airways, and Asian and American airlines specified the use of the Trent engine on new Boeing 777 orders. Australian carrier, Qantas, chose a variant of the RB211 to power its fleet of Boeing 747s. Emirates then wished to have Trent engines on its whole fleet. Production of aero-engines stopped at Nightingale Road in 2007, moving to the Sinfin site.

## 30. Co-op Central Hall (1913)

Five years after Britain's first Co-operative store had been established in Lancashire in 1844, twelve members of the Derby's Union of Carpenters and Joiners followed suit, and set up a store in Cooper's builders' yard. As the Co-op's membership base grew, in 1858 the society moved into larger premises in Victoria Street. Only a

year later, however, the spreading popularity of the society required another move, this time to Full Street.

In 1870, Robert Bridgart designed and constructed a new store in Albert Street, forming a network of stores that extended to East Street.

Branches sprang up throughout the town, and by the turn of the century, no fewer than sixty outlets had come under the umbrella of the Derby Co-operative Provident and Industrial Society. The society's assets now included five streets of small terraced houses in New Normanton, which were made available to its members for renting at affordable rates.

Just before the outbreak of the First World War, the store in Albert Street was extended. Alexander MacPherson's grand Central Hall was added, magnificent in its Baroque-revival style, complete with a copper dome, now sporting a rich green patina. Stonemasons, who worked for the society's funeral services, provided the façade with its ornate lion heads, cherubs and column heads.

For many years, the Central Hall was a popular Derby venue for live shows such as concerts, choral presentations and musician performances, as well as dances. In 1933, the hall hosted American jazz trumpeter, composer and singer, Louis 'Satchmo' Armstrong. The popular, acclaimed Armstrong was only thirty-two years old at the time of his one-night show in Derby.

In 2012, the Co-op refurbished Central Hall at a cost of £3.5 million, thereby ensuring that it remains one of the city's most attractive buildings. Shop units on the ground level are rented out, while Co-operative Travel Ltd occupies the corner of the building.

The grand façade reflects a prosperous co-operative movement at the time.

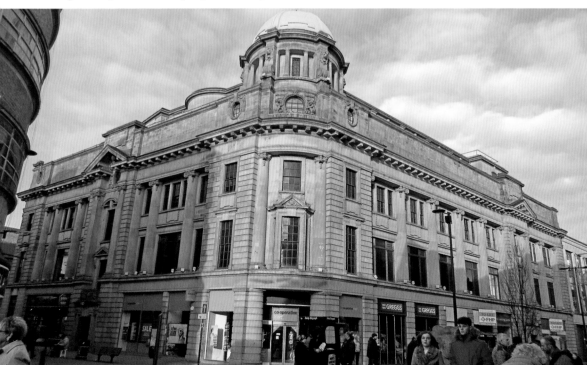

## 31. Gaumont Palace (1934)

On 17 September 1934, the Gaumont Palace, erected on London Road, opened its doors for the first time as Derby's latest and best cinema, screening the film *Evergreen*, starring Jessie Matthews as a music hall singer. With a capacity of 2,400, the interior was comfortably plush in every regard, particularly the art deco ceiling that housed the auditorium's hundreds of lights. The proscenium boasted an opulent gold frame. A ten-rank Compton organ provided the final addition.

From the pavement, a white-stone staircase, flanked on either side by brick towers, led into the recessed entrance with its marble floor.

With time, and in the face of growing competition, the Gaumont suffered a gradual loss in attendance. This downturn galvanised the owners to come up with a very satisfactory solution: one-night live performances. The likes of Cliff Richard, The Who, the Rolling Stones, Little Richard, Roy Orbison and the Kinks ensured the Gaumont's continued existence.

In 1965, the Rank Organisation closed the Odeon Cinema on St Peter Street, and the Gaumont was renamed Odeon. Nine years later, the interior was converted into three cinemas: two seating 138 each, and the third, main one, 800.

By the 1980s, Derby was down to only three cinemas. The firm ABC, having to close to make way for extensions to the Eagle Centre, then acquired the Odeon. A considerable sum of money was invested in refurbishing the interior, including restoration work to the ceiling and the installation of luxury armchairs. The old stalls area became a bingo hall. The hall was given the rather clumsy title, ABC Trocadero Entertainment Centre. It would receive one final name soon thereafter – the Cannon.

Now a pan-Asian restaurant.

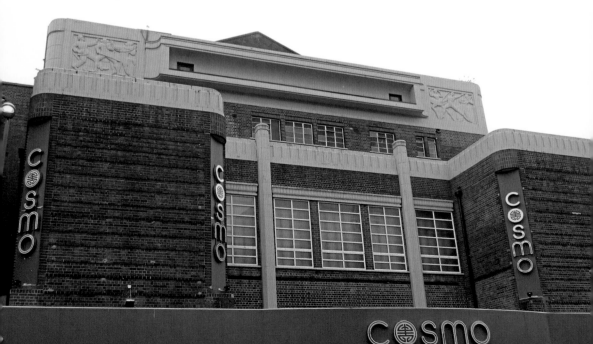

The opening in 1988 of multi-screen cinemas at Foresters Park and the Meteor retail centre then made it extremely difficult for the Cannon to compete. A partial collapse of the plaster ceiling saw the final demise of the building's use as a cinema. The auditorium remained abandoned for several years.

At the turn of the century, the auditorium was stripped down to bare walls, and the whole building turned into a nightclub and dining venue called the Zanzibar. The art deco façade was also sullied by the owners when enormous, garish fibreglass representations of an Arab sheikh and a palm tree were placed above the entrance.

The Zanzibar closed early in 2010, remaining vacant until 2013, when the 'all-you-can-eat' pan-Asian restaurant, Cosmo, became the latest occupant.

## 32. Council House (1941)

While the date in Roman numerals that appear on the building read 1941, building work was to continue on the Council House for several years beyond that date.

In the 1930s, Derby had embarked on an ambitious redevelopment programme for the central district, with the prestigious Council House being the culmination of the project. This phase included the construction of a new bus station, river gardens, an open market, and a police station. Work commenced on the Council House in mid-1938, with a target completion date of 1941. The outbreak of the Second World War in 1939, however, brought with it the immediate suspension of construction work until March the following year.

In August 1942, central government requisitioned a completed section of the building to be used by the Royal Air Force as offices. The premises would remain in a state of unfinished limbo until April 1946, but with the nation's war-ravaged economy still strictly controlled by austerity measures, when building work recommenced, progress was at a snail's pace. It was only when Buckingham Palace had confirmed that HRH Princess Elizabeth had accepted Derby Council's invitation for her to officially open the building in mid-1947, that there was a frantic drive to have certain reception areas ready for the Royal visit.

On 27 June, the mayor, Alderman C. F. Bowmer, welcomed Princess Elizabeth and the Duke of Edinburgh to Council House to perform the ceremony in front a very enthusiastic crowd.

In June 2010, it was made public that council was intending to spend more than £30 million on refurbishing the entire building. This would include stripping the interior, only leaving the façade, the demolition of a 1970s extension, a new floor built at roof level, an atrium, and a new council chamber. The plans precipitated not insignificant criticism from certain quarters, but council defended the need for the redevelopment as being an investment in Derby's future. Incorporated within the project was council's desire to end up with an energy-efficient building. To this end, state-of-the-art design work facilitated an environmentally friendly cooling system known as adiabatic cooling, where a fine mist of water is blown into the building at night, and as the fine droplets evaporate, heat energy is consumed.

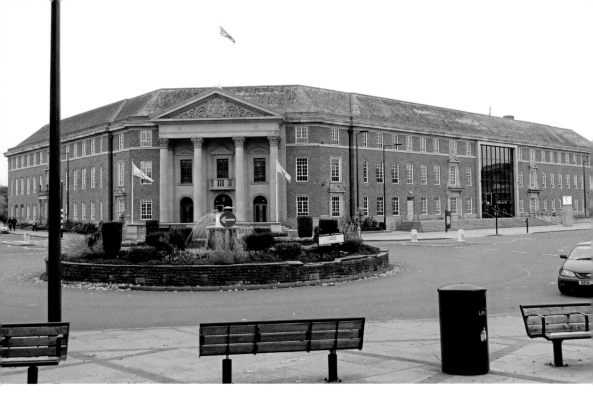

The seat of Derby City Council.

## 33. Arriva Ascot Drive Depot (1949)

In the early 1900s, the Derby Corporation Tramways still served the town, including a line along Nottingham Road up Chaddesden Hill to a terminus that had opened in 1908.

The Derby Corporation went on to introduce local buses in 1924. These were mainly Daimlers, sporting the corporation's green and cream livery.

In August 1929, Derby made the decision to follow the example set by neighbouring Nottingham and Chesterfield Corporations that had replaced their tramway services with trolleybuses. Using locally generated electricity from the Full Street coal-fired power station, the first trolleybuses went into service in January 1932.

The Nottingham Road depot, with its single entrance, presented turnaround issues, but these were not insurmountable. Depot staff became adept at transferring the transmission boom between overhead cables while the driver performed a three-point turn to start his return trip down the hill to the town centre.

By 1952, the Nottingham Road Depot was no longer able to provide an efficient base. That year, Derby Corporation closed the facility to move its trolleybus service to disused temporary Second World War buildings off London Road, which had already been converted into a bus depot in 1949, on what is now Ascot Drive. The two corrugated-iron sheds, flanking a suite of offices, would remain a bus depot to this day.

As Derby and central government delved deeply into their resources, the town became a key centre for not only the production of aircraft engines, such as the Merlin used in the Spitfire, but also repair work on airframes. As part of this war-based development, the Ministry of Aircraft Production constructed two enormous hangars on the site. In 1946, Derby Corporation agreed in council to purchase the now defunct wartime buildings from government for an amount of £68,000; the transaction took place on 18 December 1947. Work then commenced on new floors, glazing in the roof, workshop pits, a traffic room and a cash office. The converted building, which would accommodate ninety trolleybuses and forty-five omnibuses, was officially opened on 6 October 1949 by the mayor of Derby, Alderman C. F. Bowmer JP.

Soon after the Second World War, Derby Corporation rejuvenated its trolleybus fleet, the last to be purchased in 1960, Sunbeam F4As. By this time, however, the overhead cables were showing their age and needed replacing, prompting the Corporation to embark on a phased programme of replacing the trolleybuses with the so-called 'oilers', buses powered by diesel engines. The exercise was completed in September 1967.

Derby Corporation acquired Blue Bus Services in December 1973, and the following year changed its name to Derby Borough Transport. When Derby was granted city status, the company became Derby City Transport, and the livery changed to blue and cream.

The Transport Act of 1985 legislated the deregulation of Britain's bus industry, requiring the transfer of bus service operations to private companies. Overnight, competing bus operators arrived in the city, posing a direct threat to the decades-old monopoly that the council-owned operation had enjoyed. Camms of Nottingham and Mercian Midland Red slashed fares, and in the case of the latter, even offered free travel to attract punters. In 1999, Dunn Line of Nottingham acquired Camms, and relative normality returned to Derby's bus routes.

Blue Bus Services, acquired by the corporation in the 1970s as a private-hire subsidiary, became the new name and livery. To retain traditional patronage, however, many buses still carried the Derby City Transport name, while others were even decked out in the Camms livery.

In the mid-1990s, Cowie PLC, the north-east of England bus group and car dealer, purchased British Bus which, by that time, had also acquired several privatised bus companies. In November 1997, the company was rebranded Arriva PLC. The corporate aquamarine and cream livery was applied to all Arriva buses throughout the country.

A rationalisation of the company's fleet ensued, with older vehicles being retired and Citybuses brought in from London, and newer Scanias and Darts introduced. The last remaining old workhorse, Fleetline 4301, previously taken out of regular service before being painted yellow and restricted to school contracts, was finally put out to pasture in 2008 – a sad day for long-serving Arriva driver, Malcolm Lowndes, who was extremely attached to the bus, only ever begrudgingly allowing others to drive his 'baby'. Scania single-deckers and new double-deckers were then purchased and the Citybuses withdrawn.

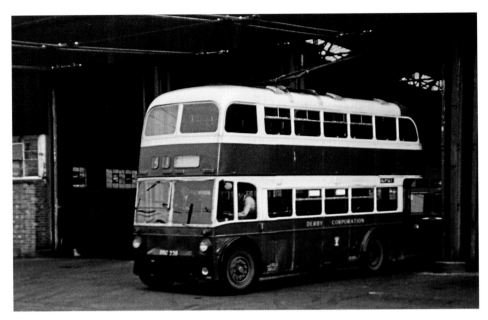

A trolleybus leaves the Ascot Drive depot, on its way to run a No. 41 Harvey Road service, *c.* mid-1960s. Derby Corporation's last trolleybus operated on 10 September 1967 (© photo courtesy Richard Woodhead).

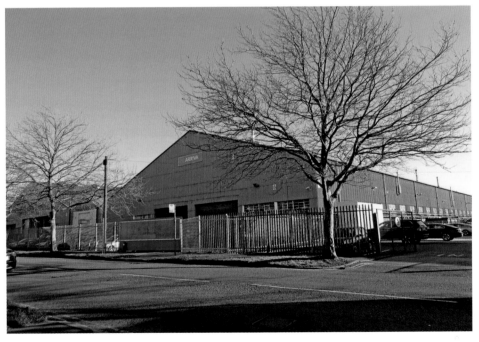

The two former Second World War hangars that were once the property of the Ministry of Aircraft Production.

In 2010, the German-based public-transport conglomerate, Deutsche Bahn, was successful in its £1.5 billion takeover bid of Arriva. The company has continued to invest in new buses to replace the aging fleet. Arriva continues to operate from the Ascot Drive depot.

## 34. Rolls-Royce OED, Victory Road (1950)

During both the First and Second World Wars, Rolls-Royce ceased car production and diverted their attention to the war effort, primarily designing, developing and producing aero-engines.

Up to the outbreak of the Second World War, W. A. 'Rumpty' Robotham had been in charge of the Roll-Royce Chassis Division. With the commencement of hostilities, the division was moved to a derelict set of buildings at Belper, where the Clan Foundry was established. The foundry was a significant contributor to Britain's war effort, becoming a major stepping stone for Rolls-Royce's Motor Car and Oil Engine Divisions.

The site worked on modifying the highly successful Merlin aero-engine for fitting into the Crusader and Cromwell tanks. Charlie Jenner led the engine design team at the 'Clan', whose down-to-earth and clear-thinking approach contributed much to the development of vehicle engines.

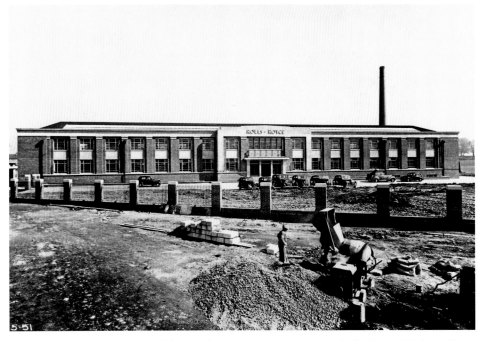

Final work at the new OED building, early 1950 (© photo courtesy Rolls-Royce Heritage Trust, Derby).

Robotham started diverting his time and energy to the design of diesel engines, or what he referred to as oil engines. His innovative, single-cylinder oil engine would pave the way for the establishment of the Oil Engine Division at Sinfin in Derby when, in 1950–51, the Clan Foundry was shut down. Arising out of a visit to the United States in the late 1940s, Robotham tested the use of light-metal alloys, which led to the design of the so-called 'C' range of diesel engines.

Constructed after the Second World War, the Victory Road office block was the base of the Oil Engine Division (OED), whose works on the Sinfin B site was established for the manufacture of diesel engines used in the construction, logging and fishing industries, as well as for Dennis fire engines.

In 1956, the OED moved to Shrewsbury, and the site started also producing jet engines. Today, it is known as Rolls-Royce Civil Aerospace (Airlines), which occupies the old OED site among others in the massive Sinfin complex. This division has become a world-leading manufacturer of aero-engines for the whole spectrum of the airliner and corporate jet markets.

More than thirty-five types of Rolls-Royce commercial aero-engines are currently in service throughout the world, the latest being the highly successful Trent XWB. With the reputation of being the most efficient and quietest large civil aero-engine in the world, it is the only engine used to power the twin-engine Airbus A350 XWB (extra wide body). This aircraft only entered commercial service in January 2015. In excess of 1,500 of these engines have been manufactured for forty-one international airlines, the most recent being the Brazilian TAM Airlines which, in December 2015, became the first operator in the Americas to add the Airbus A350 to its fleet.

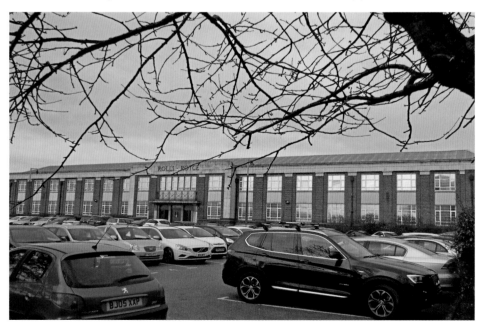

The former OED building on Victory Road today.

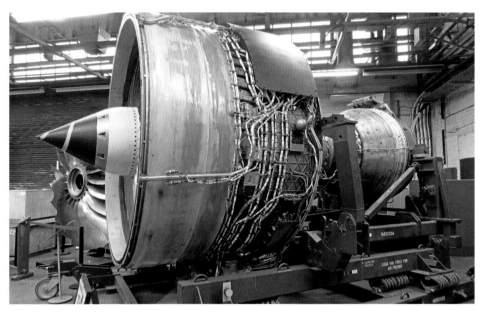

A Trent 800 with covers off, showing the complexity of modern turbo engines.

## 35. Eagle Centre (1975)

Increasing twentieth-century consumer demand prompted the start in 1971 of a major new development on the Morledge, opposite the bus station. Old housing dating back to the early 1800s was cleared, as the city council entered into a joint venture with Coal Industry Nominees, to construct a sprawling shopping complex and theatre.

In November 1975, the Eagle Centre opened its door to the public, but to a lukewarm response from shoppers. The architectural design was regarded by most as downright ugly, plus the interior was like a sauna in summer and like the Arctic in winter. The hexagonal stalls proved difficult to navigate, and market traders complained about significantly increased stall rentals compared to the old open-air market that they had vacated.

The new adjoining Playhouse, an unsightly massive cube of red brick, was decried as totally lacking any semblance of architectural artistry.

A more serious consequence, however, was that suffered by small independent outlets as their traditional patronage gravitated away to the new retail hub farther south. Shops fell empty as businesses were forced to close – the premises then taken over by food takeaways and comparatively low-overhead tenants such as estate agents and insurance companies.

By the late 1980s, the city council could no longer ignore persistent complaints about the Eagle Centre's many shortcomings. Radical refurbishment ensued – a new

Many market stalls inside the building now stand empty.

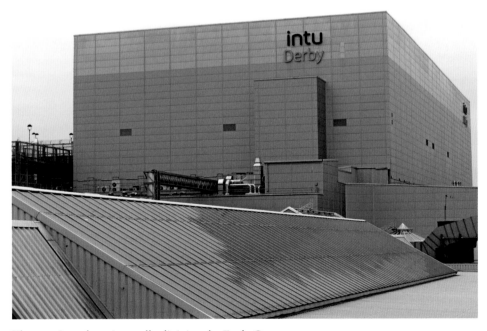

The new Intu shopping mall adjoining the Eagle Centre.

escalator-serviced entrance on East Street and the impractical hexagonal market stalls replaced with orderly rows of rectangular stalls around a central market square.

Sadly, though, an adjoining multi-storey car park was erected, straddling the Morledge. Not only did this create seemingly endless peak-time traffic problems for motorists who relied on this access route off The Cockpit roundabout, but also, yet another brick megalith did much to detract from the city's historical buildings.

The Australian-based Westfield property developer then arrived with a plan to alter completely the appearance of the site. The Eagle Centre would be revamped and incorporated into a new ultra-modern shopping mall. The aging market hall would remain untouched, a decision that would see the gradual demise of the shopping concept as stallholders failed to compete with the incomparable retail strength of their new neighbours.

The 106,000-square-metre Westfield Centre attracted many retailers new to Derby, particularly in the world of upmarket fashion. The complex boasts state-of-the-art cinemas, an 800-seat food court, and in-house parking.

On 9 October 2007, television presenter Tess Daly opened Derby's new chrome and glass retail flagship.

In the first half of 2014, London-based Intu Properties acquired the Westfield Centre, rebranding it with their own name.

## 36. Assembly Rooms (1977)

Derby's eighteenth-century wealthy spent many leisure hours in the 'Assembly' – the elderly playing cards and the younger ones dancing. A 'lady of the Assembly' or hostess, would be appointed to ensure that such dances conformed to strict social norms and etiquette. Farmers, shopkeepers, clerks and their wives were not permitted, and young maidens had to seek permission to wear either long white aprons or coats.

The popularity of these assemblies resulted in the erection in Full Street of a building named the Assembly Rooms. With time, the venue proved to be too small and not grand enough for its purpose, and in 1763 new Assembly Rooms were built in the Market Place. The building boasted ornately decorated ceilings, extravagant chandeliers and opulent drapery, and card- and tearooms. It is therefore small wonder that Daniel Defoe reputedly called it 'a town of gentry rather than trade'.

The town's original Assembly Rooms, completed in 1774, was reduced to ashes by a fire in 1963. The original façade was removed to the National Tramway Museum, Crich Tramway Village, near Matlock in Derbyshire.

The Assembly Rooms building of today was opened by Queen Elizabeth The Queen Mother on 9 November 1977. Derby City Council optimistically, perhaps naïvely, were hoping this would bestow on the new building the prestigious prefix of 'Royal'. But alas not.

The Derby War Memorial, designed by Charles Thompson, shares the market place with the Assembly Rooms.

On the evening of 14 March 2014, a fire broke out in the plantroom on the roof of the adjoining Assembly Rooms carpark. It took more than sixty firefighters to eventually bring the blaze under control, but damage to the Assembly Rooms forced its closure.

Almost a year after the fire, during which the Assembly Rooms lay unused, Derby City Council announced that the prohibitive costs of repair meant the facility would remain closed. Months later, the council decided the whole building should be demolished. A proposal to erect a temporary tented pavilion to accommodate the musical shows and recitals previously held in the Assembly Rooms was shelved, and in September 2015, the demolition option was also put on hold.

At the time of writing, the future of the concrete and brick building remains unresolved, with the council indicating that any decision will be made in the context of a city-centre vision for what the area will look like by 2030. The insurance claim of £5.5 million for fire damage is yet to be settled.

## 37. Derby Islamic Centre (1981)

In 1975, Dr Mohammed Hassan Moola headed up a board of trustees that formed an organisation called the Derby Islamic Centre, with the vision of establishing an all-inclusive Muslim community centre, incorporating a mosque. The seed was planted.

Because of concern over potential financial risk, the stagnant project was resuscitated by the formation of a non-profit, limited liability company, also governed by trustees. Within a short space of time, sufficient funds were raised,

and early in 1980, a site on Sacheveral Street that the council had set aside for the project was acquired.

The centre, to be tackled in three phases, would include a traditional Islamic mosque, a library, a social and welfare advice office, an education centre and a mortuary.

By 1981, sufficient progress had been made in the first phase to allow Derby's Muslims a city-centre place of worship. Internal work on the vaulted and domed hall was completed at the end of 1994.

The second phase, started three years later, saw the mosque extended and alterations carried out to the ground floor. An upper-floor ladies' prayer room, mortuary and community hall were added, and the car park resurfaced.

In the final phase, a minaret was erected onto the mosque, and the education centre installed above the committee room.

The Derby Islamic Centre buildings present a blend of modern and traditional Islamic architecture, the mosque emulating the style of the Dome of the Rock in Jerusalem. It also has the distinction of being the first octagonal mosque in Europe.

The centre, unique in its provision of virtually all services its community may call on, offers a full funeral service, including refrigeration, body preparation, and a hearse.

## 38. Rolls-Royce Test Facility (1985)

Test beds for evaluating modern airliner engines are contained in large solid structures, characterised by walls several feet thick, a ventilation system for good

Reflections of a multi-cultural city.

airflow, and a so-called 'detuner' that reduces the noise emitted during exhaust gases venting. Test beds are the final stage of the production process, at which newly constructed engines are tested and signed off prior to customer delivery. Tests include vibration, temperatures and rotation speeds.

Some engines can undergo 2,500 measurements simultaneously, using state-of-the-art plug-and-play technology and sensors linked to a central instrumentation monitoring facility. Inside Test Bed No. 58, an engine can be run at full thrust, without any noise escaping to the outside. The engine test rigs that hold the engines, are designed to accommodate engines with thrust levels of up to 150,000 lbs. Inside Test Bed No. 58, an engine can be run at full thrust, without any noise escaping to the outside.

In the six-year period from 1987–1993, Rolls-Royce's share of the international aviation market grew by a healthy 23 per cent. In that year, the company opened what it believed was the world's largest airline engine testing facility – a test bed the size of a football field that cost an eye-watering £20 million.

In 2006, a new test bed was constructed at the Rolls-Royce Production and Test Facility complex in Derby's Sinfin suburb. During construction, 11,000 m³ of concrete, 1,000 tonnes of reinforcing bar, and 26,000 m² of wall beams and decking were used. A further 300 tonnes of intake-silencing elements and 700 tonnes of exhaust-silencing elements completed the basic structure. Three test beds operate twenty-four hours, controlled by a team of 130 people.

A year later, Test Bed No. 58 was commissioned to develop and test two newcomers to the Rolls-Royce Trent stable – the XWB (extra wide body) and the 1000. The XWB was specifically developed to power the twin-engine Airbus A350. It proved to be the company's fastest seller, with the order book listing more than 1,000 engines.

A new test facility in Sinfin.

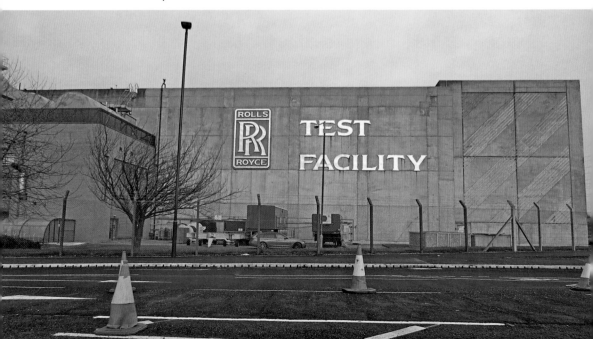

Test beds are also vitally important for the rigorous testing of new engine prototypes. Thousands of hours and millions of pounds go towards testing the airworthiness of an engine under extreme simulated conditions. The most radical – and costliest – test is that of catastrophic fan failure, undertaken to see if the fan case will contain such an event. The intake to a turbofan engine features a number of precision-engineered titanium fan blades, which, when spinning at high speed, suck in air for compression and combustion as well as providing added thrust. The test is therefore conducted at take-off speed, after an explosive device has been placed at the base of one of the fans. With the controlled explosion severing the blade (each costs the same as a family car), the destruction to the engine is unimaginable, but the fan case successfully contains the debris. The multi-million pound engine is a write-off, destined for the scrapheap.

Early in August 2010, a Trent 1000 engine, developed for Boeing's new flagship 787 Dreamliner, blew up on the test bed in Derby. The building was also damaged. The European Aviation Safety Agency (EASA) investigated, and concluded that the incident constituted an uncontained failure, meaning chunks of the engine would have been flung out at high speed. The problem was identified and remedied, and the multi-billion pound contract saved when EASA certified the engine to the highest possible standard.

On 23 November 2015, Rolls-Royce officially opened a £30 million extension to its Production and Test Facility, to provide the site with increased capacity to assemble and test Trent airline jet engines. It would now be the production centre

A Trent 1000 on Test Bed No. 57 (© photo Courtesy Rolls-Royce Heritage Trust, Derby).

for the Trent XWB, the most efficient large airline engine in the world and the fastest-selling wide-body engine in aviation history.

## 39. Derby Combined Court Centre (1989)

The Derby Crown Court, Morledge, is actually part of the HMCS (Her Majesty's Court Service). The centre was built in 1989, and is so named because the building contains both the Derby Crown Court and the Derby County Court in one convenient place. The premises were officially opened on 17 May 1989 by the late Right Honourable The Lord Lane AFC, QC, PC, 12th Lord Chief Justice of England and Wales.

Messrs Cox, Poyser and Co.'s lead foundry once occupied the site. Primarily manufacturers of lead piping, in 1809 they erected what was a Derby industrial landmark for 120 years: the Shot Tower.

Completed on 25 October 1809, the tower, built with 250,000 bricks, measured 150 feet high, with a diameter of 10 feet at the top and 28 feet at the base. Workers had to climb 196 steps to reach the top.

The sole purpose of the tower was for the production of lead shot. Inside the top of the tower, lead was melted in a large cauldron before being poured through a sieve and allowed to free-fall into a tank of water at the bottom. The result was lead pellets used as gun shot.

In 1929, Charles Aslin was appointed the Borough Architect for Derby, and given the responsibility of implementing the town's Central Improvement Plan (CIP). The massive project, involving substantial alterations to the town centre, saw Aslin designing the original 1933 bus station, the police station and magistrates' courts on Full Street, Council House, the landscaped Riverside Gardens, the third Exeter Bridge, and a covered market.

In 1932, the Shot Tower was dismantled – brick by brick – to make way for the covered market. This snippet appeared in the 16 February 1932 edition of the *Derby Daily Telegraph* and *Derby Daily Express*:

> A mummified cat was yesterday found encased in stonework at the top of the Shot Tower, the Morledge, Derby. The discovery was made by workmen engaged in demolition work. A 'Telegraph and Express' representative was informed that it was in a remarkable state of preservation. Its coat was still smooth and glossy.

The attractive covered market was an immediate success, becoming the town centre's retail and social nexus. Light-hearted verbal competition prevailed, as stall holders vied with each other for business.

The construction of a new indoor market in the Eagle Centre in the 1970s resulted in the demise of the popular covered market. The Combined Court Centre would go up on the site.

The Assizes, situated in the Shire or County Hall on St Mary's Gate since 1660, became the Crown Court in 1971, before moving to the new building in the Morledge.

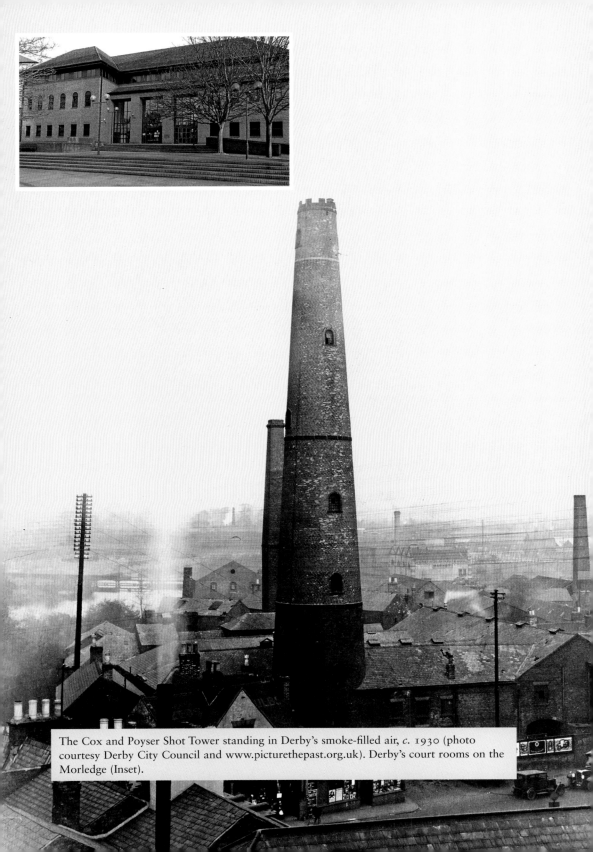

The Cox and Poyser Shot Tower standing in Derby's smoke-filled air, *c. 1930* (photo courtesy Derby City Council and www.picturethepast.org.uk). Derby's court rooms on the Morledge (Inset).

## 40. Landau Forte College Derby (1992)

The Landau Forte Charitable Trust, established in 1989, now encompasses six primary, secondary and sixth form academies across the English Midlands.

The two founding sponsors of Landau Forte College Derby, from whom the college gets its name, are the Landau Charitable Foundation, a private educational and charitable trust, and Rocco Forte & Family Ltd, the then largest hotel and catering group in the UK. While the Forte family are no longer owners of the chain, they remain major supporters of the college. Testimony to the importance of the college in the community is the fact that, among the principal sponsors, are local firms Rolls-Royce PLC and Thorntons PLC.

The college was founded in 1992 as a City Technology College – the fourteenth in the country – and became a City Academy in September 2006. With this change in status and function, came a greater intake of students for each year, in addition to a requirement for an expanded sixth form. This brought the total number of students in the academy to over 1,200, and by 2008, the intake of students had increased from an annual intake of 150 year 7 pupils to 168, with an age range of eleven to nineteen years.

To accommodate the increased enrolment, construction of a new Learning Centre was completed for the 2007/08 academic year. The new facility includes a Business Enterprise Centre, E-learning Centre, Presentation Suite, Art and Design Studios, and a teacher training facility.

Landau Forte had been established to marry the worlds of business and industry with that of education, with a synergy that would guarantee the highest quality education for Derby's youth. Consequently, demand for places remains high, necessitating an extension of the college to accommodate an increased intake together with enhanced learning facilities for the extra scholars.

The college strives to provide a unique style of education that aims to make the learning process challenging, interesting and wholly pertinent to the students' future. Embodied in this mantra, lies the importance of independent learning, the development of personal strengths and abilities, and an appreciation of the demands of future employers. Incorporated in this structure, is an understanding of the workings of modern industry and the need to equip the individual with the skills and training needed in the work place.

Personal qualities such as self-reliance, motivation and initiative are focused on, constituting elements key to exemplary and innovative citizenship within the community at large.

The college is a leading provider in the Derby Adult Learning Service, offering a diverse plethora of subjects from linguistics to cookery.

In 2012, following an inspection, Ofsted, the education regulatory authority, rated Landau Forte top in all its inspection judgements, stating,

> Landau Forte College is an outstanding academy. It has improved since the previous inspection, where it was also found to be outstanding. It excels in all aspects of its work and has made a marked improvement in the overall quality of teaching, moving it from good to outstanding.

The main reception and administration block. All college buildings are decked out in shades of cream and blue.

## 41. Guru Arjan Dev Gurdwara (Sikh Temple) Derby (1993)

The *gurdwara* (temple) was opened in Stanhope Street in December 1993, having cost £2 million to construct.

Guru Arjan (15 April 1563 – 30 May 1606), was the first martyr of the Sikh faith, having lived as the Guru of Sikhism for twenty-five years. He completed the construction of Amritsar, home to the Harmandir Sahib – the Golden Temple – the spiritual and cultural centre of the Sikh religion. This Sikh shrine attracts more visitors than the famous Taj Mahal in Agra.

Guru Arjan is most known for his writings, which, in addition to selected writings of other saints from different spiritual backgrounds that he regarded as being consistent with the teachings of Sikhism, he amalgamated into one book of holy scripture known as the *Guru Granth Sahib*. Arguably, it is the only script that is still reproduced in the original hand-written form.

Derby's Guru Arjan Dev Gurdwara Sikh Temple was established to promote the faith throughout Derbyshire, by providing a place of worship, facilities, human resources, and a community source of advice, counselling and information. It is the focal point of religious festivals, such as Vaisakhi and Bandhi Chhor Diwas and Diwali.

In addition to a full range of religious activities, the *gurdwara* is a centre for amateur sport and charity, not only providing services to a specific ethnic group, but also to mankind as a whole. It provides followers of the faith with facilities for marriages, baptisms and funerals.

The first Sikh to settle in Britain was Maharaja Duleep Singh (1838–1893), who arrived in 1854, having been exiled from India by the British Raj. In the 2011 census, 430,000 adherents of the Sikh religion were recorded in the United

Kingdom, with the vast majority residing in England. The first migrants from the Punjab to arrive in the UK was in 1911, which was closely followed by the opening in London of Britain's first *gurdwara*.

In obeyance to the teachings of their gurus, charity work is a fundamental aspect of Sikhism, with the Derby *gurdwara* being no exception. Based on the Sikh principles of selfless service and universal love, the community actively supports UK charity-registered Khalsa Aid, an international humanitarian relief agency, which recently raised money to assist relief programmes in Haiti and the Dominican Republic.

## 42. iPro Stadium, Pride Park (1997)

In 1884, the Derby County Football Club, christened 'The Rams', was formed, an offshoot of the County Cricket Club. For decades preceding this seminal moment in Derby's history of 'the beautiful game', football was a mass-participation street recreation rather than a spectator sport, epitomised in the annual free-for-all Shrovetide football 'match'.

In 1846, Derby's civic leader, after being 'severely bruised' in several physical encounters, even though he was only a spectator, lashed out, calling the annual event 'barbarous and disgusting', which had for many years 'disgraced our town'.

The Sikh temple in Normanton.

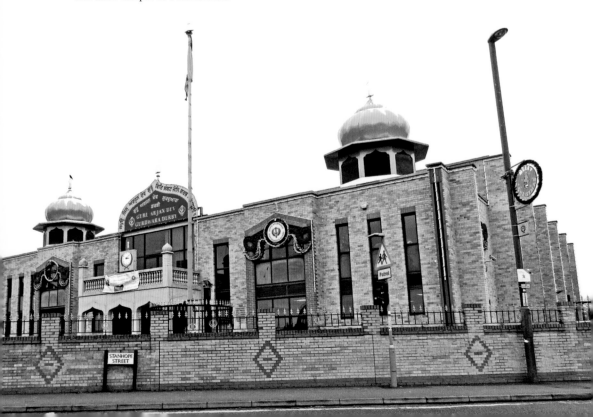

Soldiers were called in, but it was only when police managed to lay their hands on the ball and cut it to pieces, that things returned to normal and shopkeepers were able to reopen their doors. This unruly event, however, is still held annually in neighbouring Ashbourne.

The use of hands in the game was banned, and a more respectable eleven-a-side spectator sport resulted. The Rams adopted the Baseball Ground as their home where, in the 1890s, baseball was a sport growing in popularity, and one that attracted thousands of fans to every game.

At its peak, the venue squeezed in almost 42,000 supporters. The repercussions of the Hillsborough tragedy in April 1989, however, saw the legal capacity slashed to 17,500. This, together with the wooden structures in the grounds being assessed as having a high fire risk, precipitated, in February 1996, a decision by the club to move to a new stadium.

The club acquired a site in the Pride Park business park from Derby City Council for £1.8 million, and announced to its supporters that the new stadium will be ready for the start of the 1997/98 football season. The venue and new home for the club would be known as the Pride Park Stadium.

On 18 July 1997, Her Majesty the Queen opened the £22 million state-of-the-art stadium which, three weeks later, hosted the Italian club UC Sampdoria in the first match to be played in Derby County's new home. The visitors won 1-0 in front of a 29,000-strong home crowd. Subsequent expansion of capacity to 33,500 added a further £6 million to the final bill.

During Derby County's successful 2006/07 season, which ended with their promotion to the Premier Division, the club announced a £20 million investment project in the form of a plaza in the area surrounding the stadium, which would include a hotel, bars, restaurants and office space. The club's short-lived sojourn into the top league, together with American-based General Sports and Entertainment (GSE) acquiring the club in 2008, however, resulted in the plaza and proposed capacity expansion plans being scrapped. Three years later, the club was granted permission to embark on a smaller plaza project, which would only cost £7 million.

On 27 August 2010, on the north-west corner of the ground, known as Unity Plaza, a 9-feet-high bronze statue of former club managers Brian Clough and Peter Taylor was erected.

On 7 December 2013, Pride Park Stadium, following a lucrative £7 million sponsorship deal with international producers of sports rehydration, iPro Sport, was rebranded the iPro Stadium.

In September 2015, local computer games and technology entrepreneur Mel Morris – said to be Derby's wealthiest citizen – acquired the club from GSE.

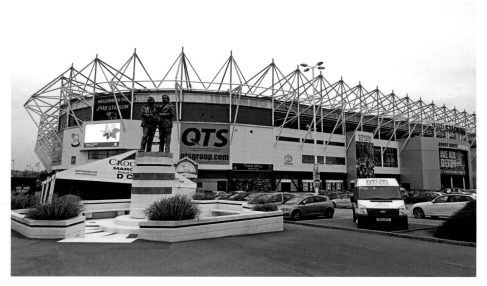

Home of Derby County Football Club, 'The Rams'.

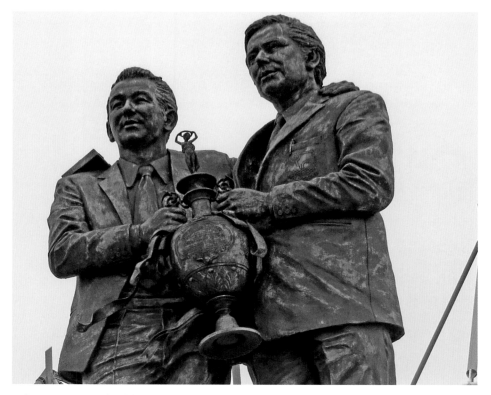

A bronze statue of celebrated managers Brian Clough and Peter Taylor welcomes fans and visitors to the stadium.

## 43. Joseph Wright Centre (2005)

Following a consolidation of its campuses in 2003, Derby College went ahead with the erection of a brand new £12 million centre, designed not only to a accommodate A Level studies, but to also offer diploma courses in, among other fields, the performing arts, music, digital media production, art and design, and sports therapy.

Initially named the Joseph Wright Sixth Form Centre – after the eighteenth-century English landscape and portrait painter, whose work encapsulated the technological and scientific progress wrought by the Industrial Revolution, the facility can accommodate 1,500 students, with many drawn from the other three existing college sites – Mackworth, Broomfield and Wilmorton.

The building is modern, incorporating an extensive use of glass to optimise the ingress of natural light and to engender a feeling of relaxed spaciousness. The building comprises a 110-seater lecture hall, science laboratories, a design studio, IT suites, a comprehensive resource centre, a shop, restaurant and on-site underground parking.

A short three years later, the popularity of the centre necessitated the adding on of the first extension, to meet a growing demand for the courses the centre was offering.

In March 2014, work started on a four-storey extension, primarily to bring together, under one roof, the two sections that make up the Creative Arts Department: the one already at the centre, and the other from the Pride Park Roundhouse campus. In turn, this will provide much-needed space at the Roundhouse for an expansion of its engineering faculty.

The Derby College's Joseph Wright campus.

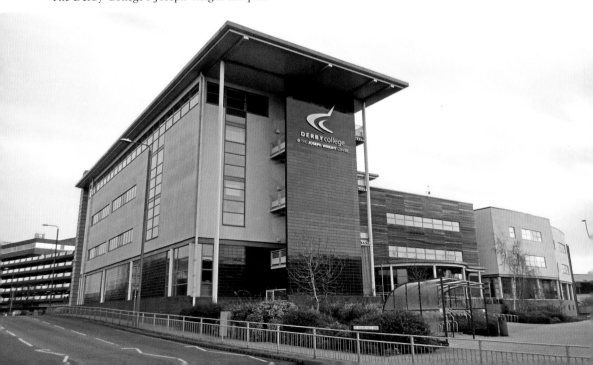

A governing body, the corporation, controls the operations and functions of Derby College. Derby giants Rolls-Royce and Toyota are represented in the corporation, reflecting not only the educational nature of Derby College as a whole, but also the importance that these top two Derby employers attach to the role of the college in their own companies.

## 44. Friar Gate Studios (2007)

The Friar Gate Studios, established in mid-2007 in response to significant growth in the city and county's creative sector has, as its Derby Connect-managed mantra, 'To inspire the spirit of collaboration and innovation'. Today, it is the base for a diverse range of creative firms.

The £2.4 million Derby City Council building, with its glass-dominated façade, is in itself a statement of twenty-first century creativity: sweeping lines, angles and curves. The steel-framed structure comprises forty-seven so-called starter units for rent, a café bar and a communal lounge. The offices vary in size, offering well-appointed accommodation for small- and medium-sized enterprises (SMEs) including the arts, design, and creative media.

Connect Derby is the organisation that manages the council-owned office space. As the name suggests, it facilitates a meeting of minds and needs of people and

The home of commercial creative design in Derby.

expertise through informed advice and the creation of jobs. The organisation aims to provide emerging businesses with the means to enable successful growth: a high-tech working environment with on-tap business support. Participant businesses include advertising agencies, architects, film producers and fashion designers.

The remarkable success of the enterprise earned the studios the honour of being the first council office space to be upgraded through its partnership with Connect Derby. Offices were refurbished and kitchens and showers renovated, in keeping with the creative ambiance of the premises.

The Bean Caffe – home of its signature banana bread – opened in the studios in 2010, and was named Best Café at the 2012 Derby Food and Drink Awards.

More recently, the spreading appearance of business signage on the front of the building drew criticism from city inhabitants, who believe that such commercialisation detracts from the architectural beauty of the building.

## 45. Quad (2008)

After many years without any form of central arts and entertainment centre, the Quad opened its doors to the public on Friday 26 September 2008. The £11.2 million radically designed building is dedicated to film and contemporary art, representing a merger of Q Arts and Metro Cinema, in association with, among others, the Derby City Council and the European Union. The building comprises two cinemas, an art gallery, a café bar, artists' studios and The Box – a venue for live shows, seminars and film screenings. The developers envisage that the Quad will become a cultural focal point in the region.

Situated in the city's historic market place, the Quad is a registered charity, and as such is reliant on funding and support from various sources, including the Arts Council England. These partnerships sustain the Quad, allowing it to create and encourage exhibitions, and to provide community outreach and creative education. Such activities, at the core of the Quad's mission, serve to provide opportunities in these fields of the arts.

All profits generated from the sale of tickets and café revenue, are ploughed back into the programme in the form of structural investment and an expansion of the programme. There are no shareholders or staff profit-share schemes. In the true sense of the word charity, the Quad continues to provide a miscellany of innovative and inspirational cultural projects and events, which are accessible for people from all walks of life.

To many purists in the community, the modern building, complete with angled pillars, is a second insult to the magnificent grandeur of the Grade II-listed Guildhall, the other perceived eyesore being the concrete-encrusted Assembly Rooms.

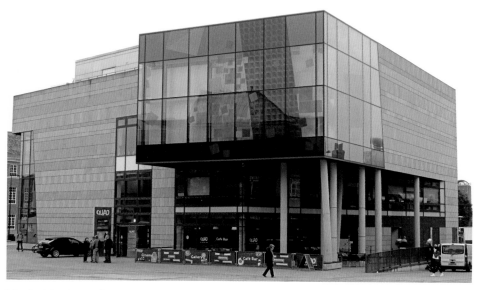

Not lacking in modern innovative design.

## 46. Bus Station (2010)

As late as 1930, Derby passenger transport services were still confined to the town centre, where a basic, decades-old network of tramcars continued to provide short-distance conveyance.

The city's first bus station was in fact in Albert Street, a small glass-roofed shed owned by the Trent Motor Traction Company. Trent enjoyed a monopoly of this facility for ten years until 1933, when Charles Aslin's bus station opened on the Morledge.

In 1932, the town's public transport changed dramatically, with the introduction of six-wheeled, double-decker trolleybuses. Two years later, the tramcars were retired. Four-wheeled Daimler buses were also introduced, but the trolleybuses remained the mainstay of the town's public transport system. Soon after the Second World War, the trolleybuses numbered 100 and diesel ones, sixty-eight.

On 2 October 1933, Derby's new bus station, adjoining The Cockpit, was officially opened. Borough Architect, Charles Aslin, who was responsible for the council's 1933 Central Improvement Plan, designed the prestigious set of curved art deco brick buildings.

The one-directional concourse was highly praised, especially with the inclusion of a café, newsagents, and council and bus-operator office suites.

Over time, however, the buildings suffered from a lack of refurbishment and maintenance. A neglected appearance evolved, and shops started to move out. Eventually, council stepped in and closed the bus station in October 2005. Demolition commenced a year later, paving the way for the Riverlights

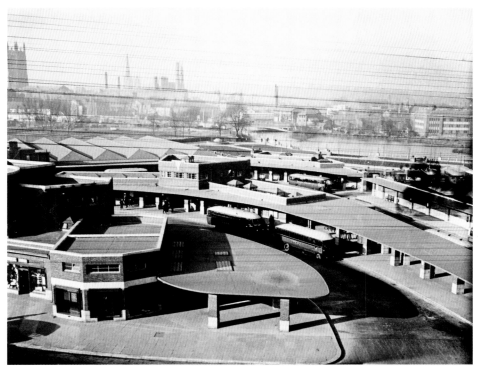

The brainchild of Borough Architect Charles Aslin (photo courtesy Derby City Council and www.picturethepast.org.uk).

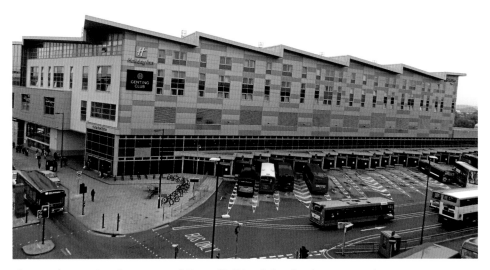

The new bus station forms part of Council's Riverlights development project.

development project, which would include the new bus station, hotels and commercial units for rental.

The new bus station opened for business on 28 March 2010, amid a flood of complaints from the traditionalists who wanted the 1933 building kept.

The saw-toothed façade accommodates twenty-four bays, from where departing buses have to reverse out. Initially, bottlenecks created by external delays in services were inevitable, severely disrupting strict windows of arrival and departure. A broken-down bus in one of the restricted exit points would result in gridlock. Open-air coach bays are positioned at the top end of the concourse.

The facility is managed by the city council that also staffs an information office on the airy, bright, but cold, concourse. A convenience store, including a café, also operates on the concourse. The main service operators, Arriva and Trent Bus, have operations rooms and offices overlooking the concourse.

The overall Riverlights project has been blighted and stalled by financial issues, resulting in plans for the proposed Olympic-size swimming pool and of the landscaped surrounds being shelved indefinitely. Allied to this, the set of commercial units on the law courts side of the building, remain almost totally unoccupied, denying council much-needed revenue from rents. Recently, one of the two hotels in the bus station closed down.

## 47. Royal Derby Hospital (2010)

At the time of its opening in April 2010, the Royal Derby 'Super' Hospital was the newest hospital in the East Midlands.

Officially opened by Her Majesty the Queen, accompanied by His Royal Highness the Duke of Edinburgh, the enormous complex can care for more than 180,000 people as inpatients, outpatients, emergency patients and day cases. This amounts to around 625,000 visits from patients each year.

The Royal Derby boasts the first roof-top helipad in the East Midlands, with its state-of-the-art intensive-care facilities and enhanced services for stroke and cancer care, second to none in the region.

The £334 million teaching hospital is designed to enhance patient privacy, by providing four-bed bays in its wards, in addition to 200 single, en-suite rooms. In the planning, an emphasis was placed on different departments and specialist services being located under one roof, in many cases generically close to each other, thereby bolstering holistic patient care.

The 1,159-bed hospital is supported by the latest technology and advances in medical science. Fourteen X-ray machines, two MRI scanners and two CT scanners facilitate efficient diagnostic procedures, while four linear accelerators are available for the treatment of cancer patients. No fewer than 300 consultants and 7,000 nurses, as well as other staff who provide medical care for the city's 660,000 citizens, run the immense infrastructure.

The Derbyshire Children's Hospital is sited adjacent to the Royal Derby Hospital. First opened in 1996, in 2010 60,000 youngsters passed through the

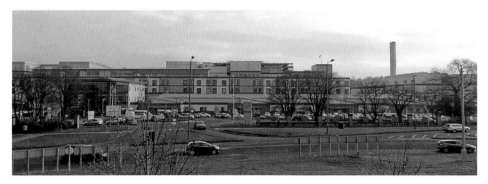

Part of the vast structure that makes up the Royal Derby Hospital. The main entrance is on the left of the photo, and the King's Treatment Centre to the extreme right.

facility. The hospital boasts an in-house school during term time and the KITE team: Kids In Their Environment, specialist outreach staff who provide home care for children with chronic illnesses.

## 48. Rolls-Royce Marine Power (2011)

In 1958, an amendment to the US/UK Mutual Defense Agreement – a bilateral treaty between the United States and Britain on nuclear weapons cooperation – paved the way for the transfer of basic reactor technology from Westinghouse in the USA to Rolls-Royce, UK. This included the S5W (Submarine platform, Fifth generation, core design by Westinghouse) nuclear propulsion plant used by the US navy at the time for propulsion and the generation of electricity on its warships, as well as being the standard reactor for submarines. This allowed Rolls-Royce in Derby to design, manufacture, develop and maintain submarine reactors, as wells as produce the fuel rods. Rolls-Royce would become totally self-contained in the whole spectrum of technology associated with submarine nuclear-reactor development.

In 1959, Rolls-Royce & Associates was formed, the latter comprising the firms of Vickers, Foster Wheeler and Babcock & Wilcox. In August the following year, the manufacturing site on Raynesway, Derby, was licensed, and went into the production of PWR nuclear reactor cores for British submarines, such as the latest Royal Navy's Astute-class attack boats. In November 1961, a further licence was granted for the Neptune Radioactive Components Facility Site – also on Raynesway – that houses the Neptune test reactor used to carry out experiments on reactor cores. The site, comprising a low-power test reactor and two associated facilities, supports the British naval nuclear programme, and as such, details about its activities are deemed sensitive and therefore precluded from the public domain.

Today, the Raynesway-site complex still manufactures submarine nuclear reactors and fuel cores for the Royal Navy, including for the Vanguard-class submarines that carry the Trident submarine-launched ballistic missiles, which are armed with thermonuclear warheads.

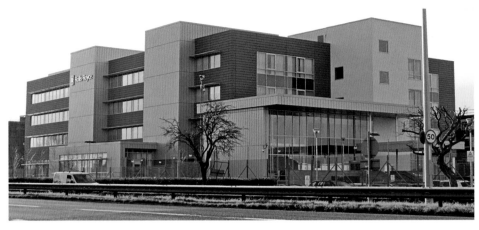

The latest addition to Rolls-Royce's marine power facility on Raynesway.

The Associates were bought out in the 1990s, and the company became a solely owned subsidiary of Rolls-Royce PLC. The company was retitled Rolls-Royce Marine Power Operations Ltd.

In February, Vice-Admiral Sir Andrew Mathews KCB, FREng, Chief of Materiel (Fleet) and Chief of Fleet Support, performed the ground-breaking ceremony at Raynesway site for a new multi-million-pound Core Manufacturing Facility, to replace existing production buildings.

The new facilities manufacture highly enriched uranium fuel modules and reactor cores for future nuclear-powered submarines for the Royal Navy, including boats that are scheduled to replace the current Vanguard-class submarines. Supporting 300 jobs, and with a billion-pound deal in the order books, it is believed that Rolls-Royce Marine Power's partnership with the Ministry of Defence is secure for decades to come.

## 49. Council Hydropower (2013)

The River Derwent has, for many years, been a source of energy, powering silk and cotton mills throughout the Industrial Revolution. The first successful water-powered cotton-spinning mill was that of Sir Richard Arkwright, built at Cromford which, in fact, was the crucible of the Industrial Revolution. Today it is part of the Derwent Valley Mills World Heritage Site.

More than 200 years on, Derby City Council boasts its very own hydroelectric power plant, which was included in the Council House refurbishment project to provide power directly into the building. The site chosen for the construction of the hydroelectric power generator was on Longbridge weir on the River Derwent, a stone's throw from Council House.

From the outset, however, the project was fraught with a plethora of financial, technical and legal difficulties, resulting in lengthy delays. The firm Derwent Hydro presented council with their feasibility study in 2006, which was approved by the council the following year. Arguably, though, the biggest hurdle proved to be that of

gaining permission from the Environment Agency (EA) for Council to tap into the Derwent.

The greatest challenge, which had the potential of derailing the project, was the EA flood-defence team's concern about the likely impact that the rechannelling of river water would have on downstream water levels. The team required a model representation of the facility to test the likely consequences of a one-in-100-year flood. For the council, the result was good news, as the model showed that any such extreme flood event would only have a minimal effect on river levels. This was also an expensive exercise, however, resulting in a substantial overrun of the budget set aside for planning permission within the £2 million project. A licence was finally granted in 2009, but the project was now six months behind schedule.

The next hurdle was purely legal. Legislation promulgated in 1976 prevented councils from selling surplus power generated by renewable means, unless it was generated in association with heat. While this surplus would only amount to eight percent, for the council this revenue was important to the financial plan of the project. The council had to resort to the services of a law firm to lobby for an amendment to the existing legislation.

In August 2010, the solicitors' campaign brought about the changes the council was after.

Work could eventually go ahead. The generation of power only commenced in March 2013. Total generation from March to the end of November 2013 exceeded 570,000kWh.

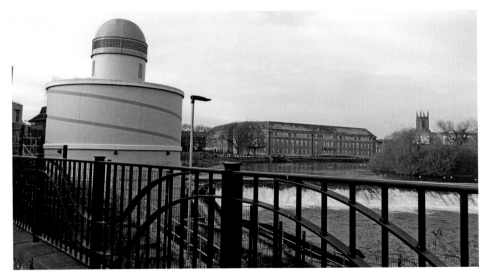

The green-domed building that houses the council's hydropower generator, which supplies electricity to Council House, seen here in the middle of the photo.

## 50. Derby Arena (2015)

Work commenced in 2012 on Derby City Council's prestigious, state-of-the-art arena and velodrome.

Situated close to Derby County Football Club's iPro stadium in Pride Park, the £27.5-million development project forms a significant element to the Derby City Council's Leisure Strategy.

While essentially a centre for sports and related physical activities, the new arena also serves as a venue to host university graduation days, exhibitions, marketing seminars, conferences and a wide range of cultural events. In terms of capacity, the velodrome can accommodate 1,700 spectators, while other non-sporting events can seat 5,500.

The velodrome track was designed by the German specialist company, Velotrack and is similar to the one at the Manchester National Cycling Centre. They also sourced and laid the 26 miles of wood used in the construction of the track. Some 265,000 nails were hammered in by hand during the six weeks it took to lay the track.

In addition to the cycle track, the Arena boasts an all-accommodating array of facilities: an infield the size of thirteen badminton courts, which can stage badminton, netball, football, table tennis, martial arts and volleyball events; a cycle centre offering hire, repair and storage; a sophisticated 150-station gymnasium; exercise studios; meeting and hospitality rooms; a café and bar; and spacious changing rooms.

The gymnasium boasts some of the latest professional cardiovascular equipment, such as Excite+. Connections to MyWellness Cloud, will record an individual's activities inside and outside the gym, thereby providing progress data as a measure of performance. Equipment in the gymnasium is Inclusive Fitness Initiative (IFI) Accredited, which means that it has been designed and fitted to allow for optimum accessibility. This enables those with disabilities to benefit as much as able-bodied individuals from a full body workout.

A stylised interpretation of the indoor, wooden cycle track cloaks the Derby Arena.

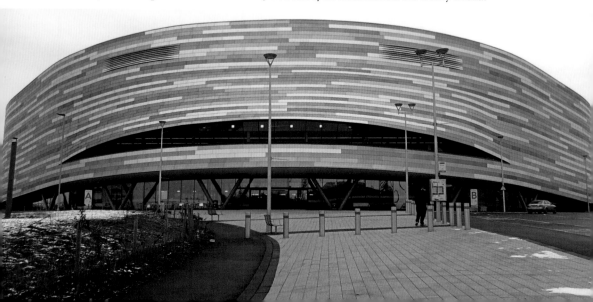

# Acknowledgements

In compiling this book, I have, almost without fail, had the most incredible and spontaneous assistance from individuals who share my passion for historical research. This bodes extremely well for the preservation of Britain's historical heritage.

I make particular mention and extend my sincere gratitude to Nick Tomlinson and his team at non-profit-making Picture the Past, who operate in partnership with, among others, the Derby City Council. Their website is a veritable treasure trove of Derbyshire images: www.picturethepast.org.uk

Grateful thanks to Peter Collins of the Rolls-Royce Heritage team for giving me so much of his time, assisting with archival photographs and gems of information.

Thanks also to Sandra Hull from Friends of Elvaston Castle, who lobby tirelessly for the preservation of this magnificent castle and gardens, and to Craig and the staff of the National Trust at Kedleston Hall.

Thank you to staff at the Derby Museum for allowing me personal access to the inside of the historically rich St Werburgh's church. The Churches Conservation Trust do a magnificent job of preserving the church, one of 300 in Britain that benefits from their hard work. Thanks to Richard Woodhead for so kindly and willingly sharing the material he has of the Ascot Drive bus depot.

These two publications provided a good insight into Derby's early days. If you can find them, they make for very good reading: Davison, A.W., *Derby: Its Rise and Progress*, Bemrose and Sons Ltd (London, 1906) and Richardson, Dr W. Alfred, *Citizen's Derby*, S.R. Publishers (Wakefield, 1949).

Unless specifically stated, all photographs courtesy of the author.

This publication is dedicated to Tracey, my Derby-born-and-raised wife of thirty-five years, and to whom I owe so much in my life.

# About the Author

Born and raised in the then British colony of Southern Rhodesia, full-time historian, researcher, copy-editor and published author, Gerry van Tonder, came to Britain in 1999, settling in Derby, the city of his wife's birth.

Since then, Gerry has undertaken extensive private and commissioned research, specialising in military history. To date he has had three books published, including the co-authored landmark definitive *Rhodesia Regiment 1899–1981*. A copy of this book was presented to the regiment's former colonel-in-chief, Her Majesty the Queen. A further two of Gerry's books in this field are due for release in 2016.